DERBY
THROUGH TIME
Maxwell Craven

AMBERLEY

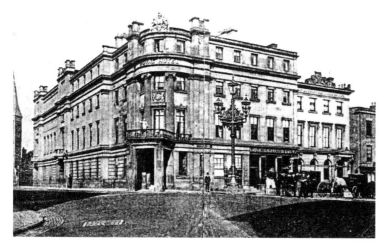

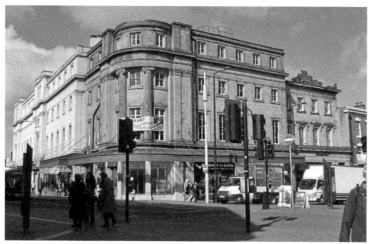

Victoria Street

Derby's Royal Hotel was designed by Robert Wallace of London and built in 1839 (LGII), in Victoria Street. Here we see it in the 1860s (as captured by Keene) and June 2014. It ceased to be a hotel in 1946; it was shorn of its cresting and portico, with its turn-of-the-century canopies simplified. Wallace also designed the Derby & Derbyshire Bank, adjacent to the Royal Hotel (1837/38, LGII). The elaborate 1840s gas lamp standard was moved to the junction of Duffield and Kedleston Roads when electricity was introduced in 1893 (giving the name Five Lamps to the area), and was finally scrapped in 1943. Today there is far too much clutter on the street [*Private collection*].

First published 2014

Amberley Publishing
The Hill, Stroud,
Gloucestershire, GL5 4EP
www.amberley-books.com

Copyright © Maxwell Craven, 2014

The right of Maxwell Craven to be identified as the
Author of this work has been asserted in accordance with
the Copyrights, Designs and Patents Act 1988.

ISBN 978 1 4456 4052 5 (print)
ISBN 978 1 4456 4085 3 (ebook)

British Library Cataloguing in Publication Data.
A catalogue record for this book is available from the
British Library.

Typesetting by Amberley Publishing.
Printed in Great Britain.

Introduction

Derby is a city of abiding interest. It began (after a false start with the Roman town Derventio, a mile to the north) with a minster church founded in the late seventh century, and a Saxon *burh*, established in the early tenth century. From then until 1154, it boasted a fairly prolific mint, and became the county town from the sixteenth century until 1959. It lays claim to England's first factory, the Silk Mill of 1718. The mill set the trend for high-end industry, serving the needs of the local gentry by producing silk, fine porcelain, clocks, architectural ironwork and calicoes.

The eighteenth century saw John Whitehurst and Erasmus Darwin, both long-term residents, co-found the Lunar Society with Matthew Boulton. In this era Derby found itself at the van of the Midlands Enlightenment, matchlessly illuminated by Joseph Wright ARA and a close-knit circle of creative people, whose work underpinned the great entrepreneurs, such as Jedediah Strutt, William Duesbury and Thomas Evans, among others.

Strutt's son, William, chaired the Regency Improvement Commissions. He oversaw a radical overhaul of the town's medieval infrastructure, and coming of the railways in 1839. This was an era of heavy industry, which culminated in the building of railway equipment from 1844, and the arrival of Rolls Royce in 1907 (initially also a high-end manufacturer, until the making of those incomparable motorcars was moved to Crewe in 1939).

I have attempted to specify further about this history through the captions. To any reader who requires the full 2,000 year sweep, or the minutiae of some nook or cranny, I can only recommend my *Illustrated History of Derby* (2007), or the Internet.

I have sought to combine views that seem to be unchanging, with examples of moderate change, and indeed wholesale transformation. While none of us are against change, what tends to emerge is that, in Derby, it has been unnecessarily drastic; the replacement buildings have been of notably poor quality on the whole. Other municipalities have managed such transformations a great deal more successfully.

Acknowledgements

Compiling pictorial books about Derby is something that requires photographs, which sets a challenge. So many old photographs of the city have been published more than once that – and I bear my share of the responsibility for this – to find fresh material is a challenge.

I was helped in this when, some twelve years ago, I attended an auction in Derby, presided over by my friend James Lewis (who went on to found Messrs Bamfords Ltd, auctioneers of Derby). I bid on a typical mixed lot of books, magazines, old documents and photographs. The photographs turned out to be of unusual interest, having been largely taken during the first half of the twentieth century by a number of photographers, including Charles Barrow Keene FRPS (1859–1937), Charles Bakewell Sherwin (1877–1950) and the late Frank William Scarratt (1876–1964).

Keene was a younger son of Derby's pioneer Victorian photographer, Richard, and also a professional photographer, whose shop in the market place closed in 1936 – the year before he died. Sherwin was assistant borough surveyor in the 1920s, grandson of an alderman who had refused the town's mayoralty several times. He was an elève of Keene's and an assiduous recorder of Derby's topography.

Frank Scarratt was the son of a Derby cab proprietor, who worked as a photographer and postcard publisher. He produced thousands of postcards over a career that stretched from c. 1906 to the immediate post-war period, many of which are exceedingly rare. Some of the pictures in the lot I bought matched his postcards; others may well do so too, to the *cognoscenti*. Others were perhaps taken for record purposes. Attributing individual pictures from this accumulation where it was not obvious has been a challenge.

A few of this trove were dated, most are datable, and I have supplemented them with the work of others, to whom I am most grateful. I am especially grateful to Derby Museums Trust, over whose collection I once presided, and Derby Local Studies Library (acknowledged as DLSL). I have used a number of images taken for the council by Messrs Hurst & Wallis in the 1930s. Some I rescued from a council skip in 1988, and others were kindly given to me by Graham Penny, another notable auctioneer, whose father William was for many years borough surveyor. Thus, in the pages that follow, unacknowledged 'before' photographs are from my auction find. Others are acknowledged in the usual way in italics, along with the photographer and date where known. All the modern shots are my own. Also in the captions, I have put the date of building, architect and statutory listing (e.g. LGI, LG II*, LGII and now redundant LGIII) in brackets after the first mention.

Finally, I would like to acknowledge Wendy Bateman for allowing me access to the Cathedral Gallery, Mrs Patricia Cannon for the photographs taken by her relative Margaret Goodey, the Derby Museums Trust, the *Derby Telegraph*, Don Gwinnett (whose collection includes many of the best Scarratt postcards), Derby Local Studies Library, Monica Meren, James Richardson and Nick Smith of Smith of Derby Ltd. I have also been greatly helped by four good friends, all who have all died in the last few years: Roy Christian, Frank Rodgers and Edward Saunders. The aforementioned gave me copies of photographs they had taken, to use and Don Farnsworth, a photographer of enormous experience and an indefatigable recorder of Derby, copied several Keene originals for me. They are all much missed, but I hope that their contributions to this little book will stand as something of a memorial to their efforts. I also owe a debt of gratitude to two other private collectors of local postcards, who have allowed me to use gems from their collections.

The enthusiastic assistance of my wife, Carole, in casting a critical eye on the end product and driving me round while I tried to match earlier scenes with current ones, is beyond praise.

In conclusion, all errors are exclusively my own.

Maxwell Craven
June 2014

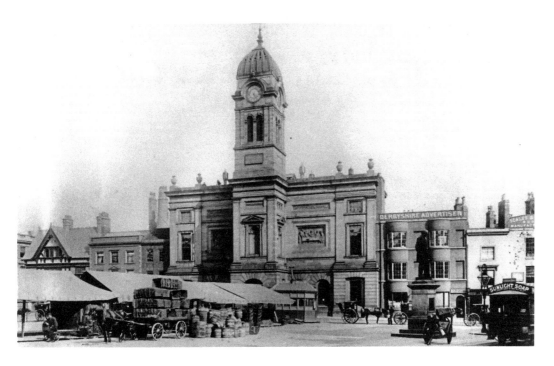

Market Place, Guildhall

Archaeology has established that Derby Market Place came into being around 1100. A guildhall lay in the middle of the area from at least the fifteenth century, but in 1828 Matthew Haberson designed a new, neo-Greek guildhall for a new site on the south side. This burnt down very spectacularly on the night of Trafalgar Day, 1841. It was replaced by the present edifice, reusing parts of its predecessor, and was designed by Henry Duesbury, then built in 1842 (LGII). *Photograph by Richard Keene c. 1888 [Derby Museums Trust L58].*

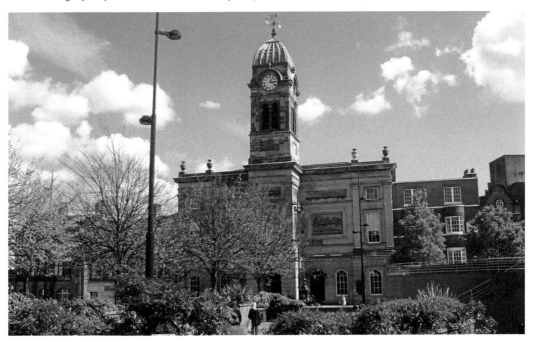

Tenant Street

To the left of the guildhall, as one looks at it, Tenant Street runs southwards. On the Market Place corner from the 1860s was Britannia Buildings (locally 'Philipson's'), designed by Benjamin Wilson, always a pedestrian architect. It was destroyed in the early 1980s to make way for a five star hotel, which was never built. Instead, in 2008, Derby Quad Arts Centre was opened, architecturally *passé* and pretentious, a councillor's ego trip, taking its cue from the awful Assembly Room and not the modest Georgian buildings beside it. Nevertheless as a venue, it has proved a modest success.

Photograph of c. 1932 probably by C. B. Keene, whose premises were close by.

Market Place, Assembly Rooms

A combined town and country assembly rooms was built in 1763 to designs of Washington Shirley 5th Earl Ferrers and Joseph Pickford; the interiors were Neo-Classical by Robert and James Adam (LGII). In 1963, a minor fire prompted demolition of all but the façade, but the architect of the replacement building – another municipal ego trip – Sir Hugh Casson, refused to incorporate the old façade into his overbearingly brutalist design, despite having been requested to do so, so it went to Crich Tramway Museum instead, where it may still be seen.
Photograph c. 1962, possibly by Frank Scarratt [Derby Museums Trust].

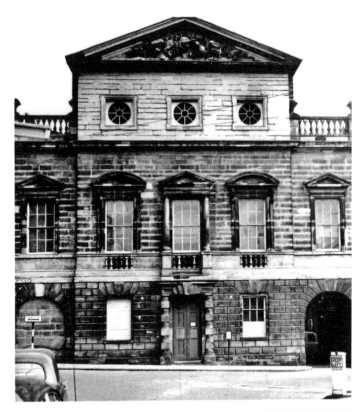

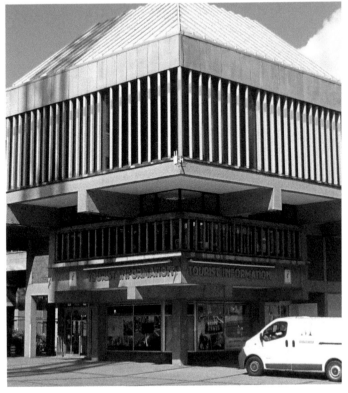

7

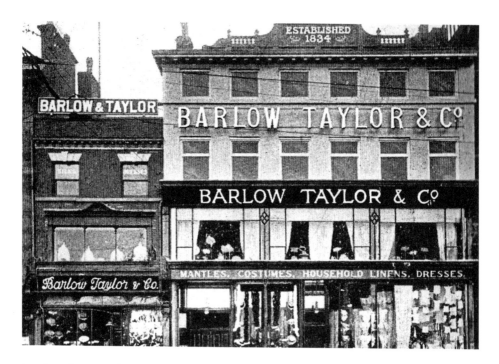

Market Place, Market Head

A view of Barlow, Taylor & Co.'s drapery store on the west side of the marketplace, an area known from time immemorial as 'Market Head'. George Beswick founded the store nearby in 1844. It became Beswick & Smith a decade later and was taken over by John H. Barlow in the 1880s, when the first floor display window, plate glass fenestration and cresting were added to the eighteenth-century building. Now it is an Australian themed pub called Walkabout. *Photograph from a 1909 trade directory.*

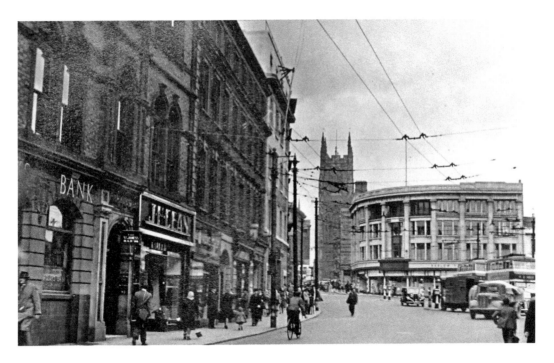

Corn Market, Looking North

Barlow Taylor moved across to the north side of the marketplace in 1925, into a new store (*above, right*) by Naylor & Sale. Closed since the 1980s, the building is now divided between a cafébar and betting emporium, with flats above. The marketplace itself was a car park when the original photo was taken, ringed with trolleybus wires. Today it is cluttered up with plants and a water feature from 1990 by Walter Pye. Corn Market leads to Iron Gate (*cf. No. 6*) and thence to Queen and King Streets, all sections of a prehistoric track that ran up the ridge on which Derby stands, long before the foundation of the town. *Photograph, probably by Scarratt, dated 1947.*

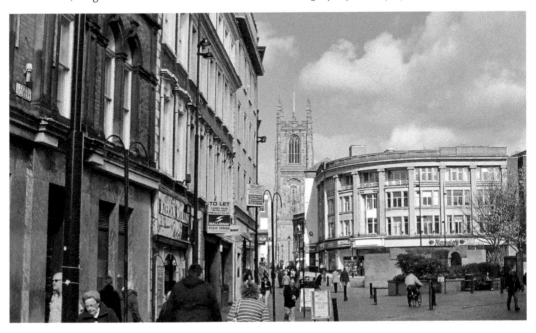

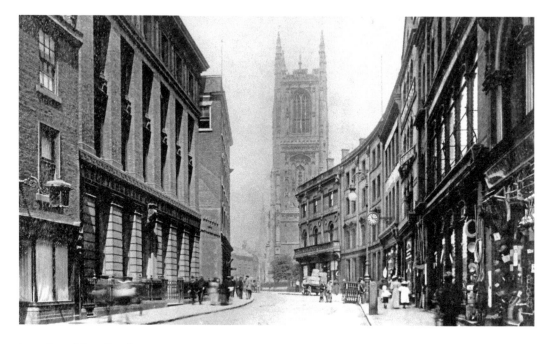

Iron Gate, View North

A late Victorian view of a street that in the fourteenth century actually had a concentration of ironmongers and smiths. The building nearest the left (part of the birthplace of the artist Joseph Wright ARA) was replaced in 1906 by an Arts and Crafts shop/office, a change more in keeping than the two 1960s blocks visible in the recent view. The building beyond was Crompton & Evans Union Bank, later NatWest Bank (J. A. Chatwin, 1880, LGII), converted into a pub called the Standing Order in 1992. The 1530 perpendicular tower of the cathedral (John Oates, 1511–31, LGI) dominates. *Photograph of 1894 possibly by Richard Keene Jnr. [Derby Museums Trust L. 166].*

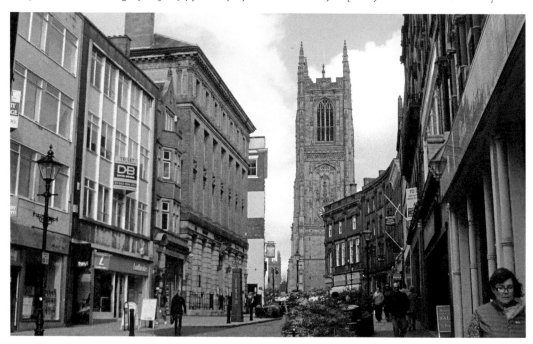

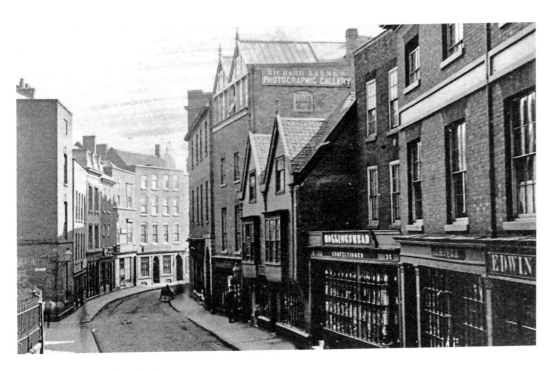

Iron Gate, View South

In 1866, the corporation widened the east side of Iron Gate – an element of the main north–south route through the city – to ameliorate traffic congestion. It was the first of a series of widenings lasting until the 1920s. Here in May 1855, the street is more or less as it was in the 1750s, when John Whitehurst FRS and the young Joseph Wright lived virtually side-by-side. Whitehurst resided in the house to the left of the small doubled gabled building, which was later occupied by photographer Richard Keene. *Photograph by Richard Keene [Derby Museums Trust].*

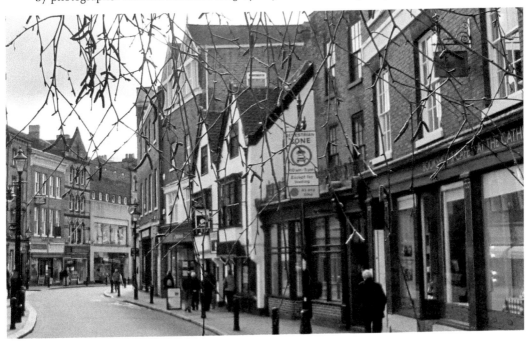

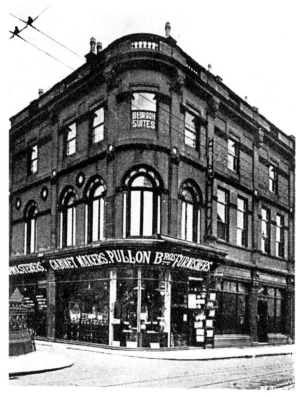

Amen Alley, Corner of Iron Gate

As part of the 1866 widening of Iron Gate, the whole east side replaced, the plots being sold by tender. The one on the corner of Amen Alley (which forms the southern boundary of the Cathedral churchyard) was designed by Benjamin Wilson (*see p. 6 above*). His articled clerk, Frederick Woodward wrote in 1870 'we have got the largest job of the lot, the rebuilding of the houses at the corner of Amen Alley [now Emily Brigden] and a heavy job my governor made of it. That which should have been the handsomest building in the street has turned out to be perhaps not the worst, but certainly not the best ... I do not aspire to the honour of having had a hand in the making of it...' Today it looks threatened by the Orwellian CCTV camera on its thick pole. *Photograph from a 1909 trade directory.*

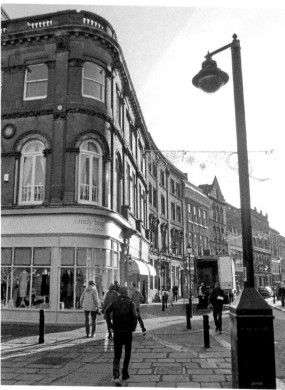

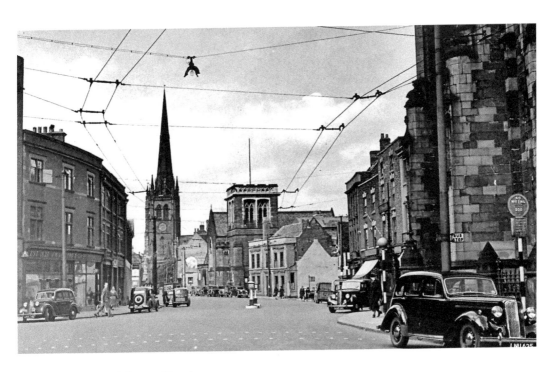

Iron Gate and Queen Street

In the modern view, Henry Stevens' St Alkmund's church (1846) has gone, revealing the 1838 tower of Pugin's St Mary (RC) behind (LGII*). St Michael's (Henry Stevens, 1858, LGII) remains in the centre of the scene, with the tower of the cathedral (before 1927, All Saints parish church) to the right. Also gone are the trolleybus wires. The building, left on the corner of St Mary's Gate, has recently been heightened. The Humber Hawk (right) has been replaced by a Toyota Prius. *Photo stamped on reverse, 'Air Ministry, Dec. 1940'. Modern photograph May 2012.*

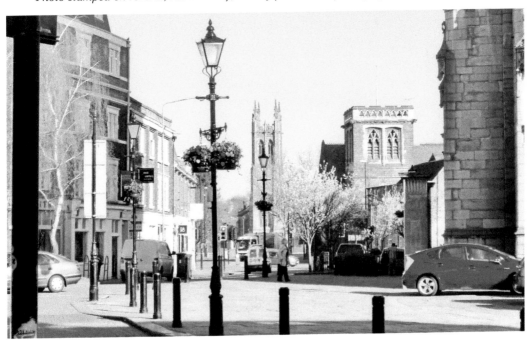

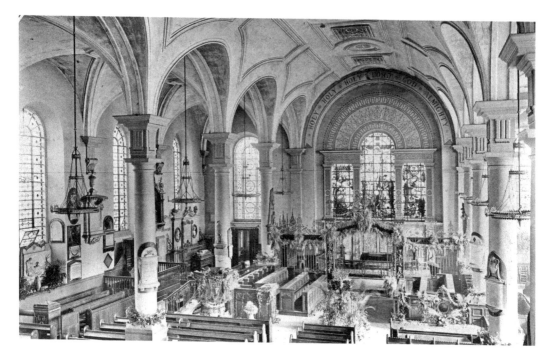

Queen Street, Derby Cathedral

The interior of the former All Saints church nave (James Gibbs, 1723–25, LGI) is a tour de force of light and airiness, although above it is seen after a particularly insensitive reordering by Julian Young of 1870–1873. The celebrated wrought-iron screen by Robert Bakewell (1682–1752) can be seen in both views. In 1969–71, the Venetian window was removed and the church extended eastwards by Sebastian Comper, in order to create a retro-choir, song school and meeting rooms. *Photograph by Richard Keene* c. *1875*.

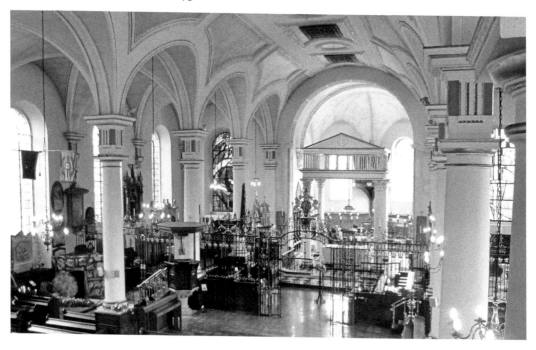

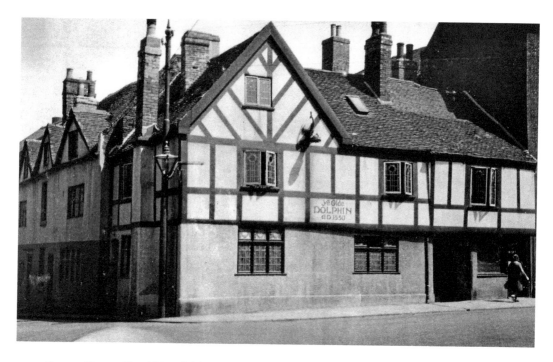

Queen Street, The Old Dolphin

The name of the inn has religious overtones, in keeping with its claim of foundation by the College of All Saints in 1530 (although there is no written evidence to support this claim). The building is early seventeenth century (LGII), despite *faux* timbering painted on the overlying stucco in the early image. After the war, the stucco came off, the rotted original timbers had to be replaced, and the range facing Full Street (*left*) was heavily truncated. It is one of the few city centre pubs to retain actual rooms. The setting is spoilt by a superfluity of irrelevant street furniture and signage. *Photograph c. 1930 by Margaret Goodey, courtesy of Mrs. P. Cannon.*

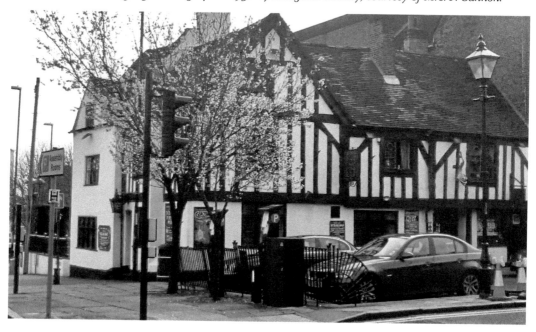

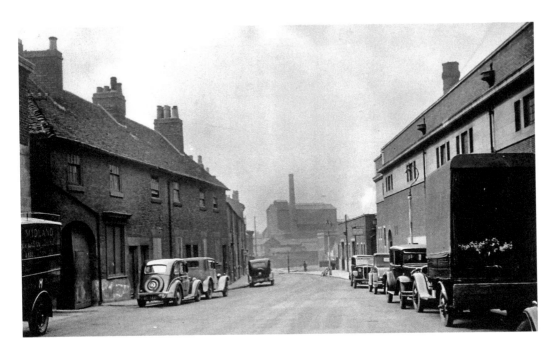

Cathedral Road and Walker Lane

Walker Lane was straightened, widened and renamed Cathedral Road as part of the 1930s Central Improvement Plan. Slum clearance was achieved at the lower end, and C. H. Aslin's handsome baths complex was built adjoining Queen Street, the side of which can be seen here (*right*). The former Bluecoat Almshouses on the left (long secularised) were swept away in 1929, by Messrs Kennings, to expand their motor emporium (Wilcockson & Cutts of Chesterfield), which is just visible on the far left. The huge mill in the background is the steam silk throwing mill of Thomas Bridgett & Co., 1827 (LGII*). *Photograph dated 14 March 1938, probably by C. B. Sherwin.*

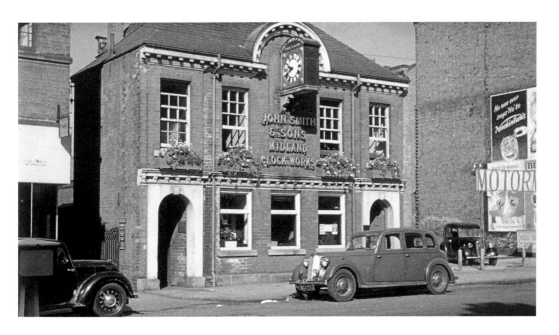

Queen Street, Smith's Clocks

This little house is all that remains of a much larger edifice erected by the father of Revd John Flamsteed (1646–1719), England's first Astronomer Royal. It was enlarged for John Whitehurst FRS, by architect Joseph Pickford, in 1764. Joseph Wright ARA lived here from 1793 until his death, four years later. In 1865, John Smith moved his clockworks here; the firm remained until 1999, during which time the portion to the left was demolished to improve access to the works behind. The whole façade was removed in 1924 to allow street widening. The then proprietor Howard Smith's Rover can be seen parked outside. It is unlisted and has been derelict for fifteen years, yet because of its associations, it is one of the most precious survivals in the city. *Photograph of 1952 by J. E. Howard Smith [Smith of Derby Ltd].*

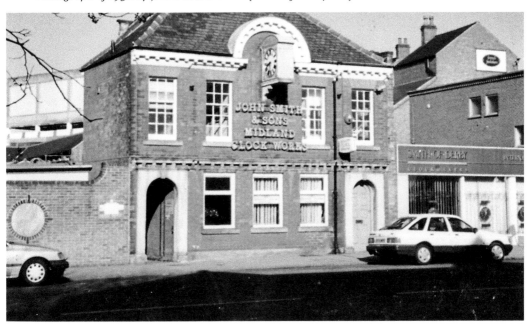

St Helen's Street, Marble Works

A marble works was established on this site, at the corner of St Helens Street and King Street, in 1806. It was established by petrifactioner Richard Brown (1736–1816), being the site of Old St Helen's House, itself fashioned from the hospital of St Helen (part of the Abbey of Darley), at the Reformation. Here we see the later showroom, with Brown's house beyond. Behind the showroom (demolished in 2005 to extend the inner ring road) lie the original works, which are partly visible (*extreme right, below*) where the waste heat from a 6-hp steam engine heated Derby's first public swimming pool from *c.* 1820. *Photograph by the late Don Farnsworth, 1970s.*

Bridge Gate

Bridge Gate (the 'gate' suffix is Norse for 'street', a measure of antiquity) was pitched along the late Saxon town ditch that defended the borough from the north, by linking the Derwent with the Markeaton Brook to the west, at the same time that the first bridge was built around 1200. The spire is that of St Alkmund, a minster church founded some 250 years before the Saxon *burh*. The tower is that of Pugin's St Mary (1838), a view today hopelessly compromised by the towering inconsequence of the plastic clad Jury's Inn (2009). The entire scene was razed in 1967 to build the inner ring road.
Photograph by Margaret Goodey, 1930.

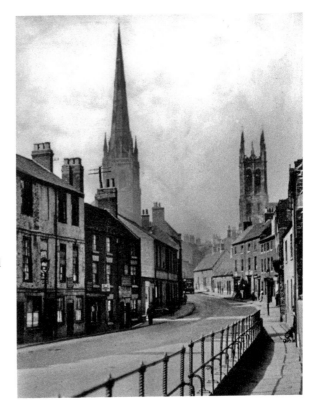

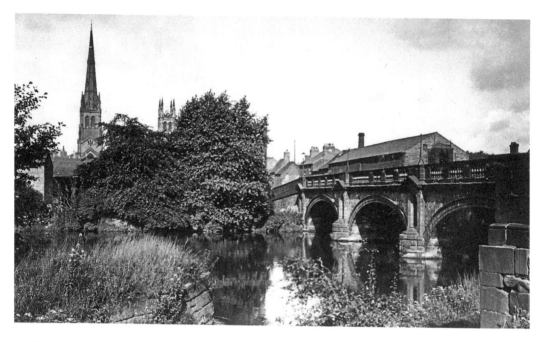

St Mary's Bridge

The first bridge over the Derwent since Roman times dated from just before 1200, and marked the route to Nottingham. It was replaced by the 1788 Improvement Commission – the first chaired by William Strutt – and completed in 1794 (Thomas Harrison of Chester, LGII). On the opposite shore, hidden by trees, lies Derby's early fifteenth-century chapel of St Mary-on-the-Bridge (*centre left*). This is one of one six surviving bridge chapels in England (LGI), reinstated for worship in the nineteenth century and tactfully restored by Percy Currey in 1930. The attached house (LGII) dates from 1700 and was long the home of the Eaton family, who, in the eighteenth century, used the chapel as their hosiery works. *Photograph of c. 1930 by Margaret Goodey.*

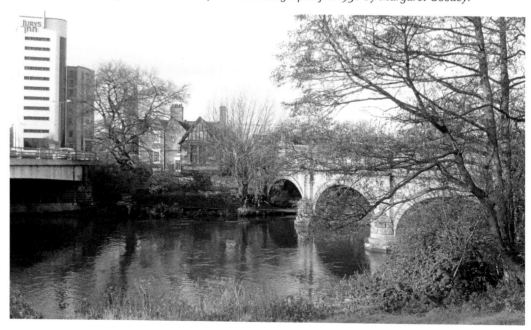

St Michael's Lane

Returning back along Queen St, one comes to St Michael's Lane (its name is derived from the ancient church on the corner of Queen Street), which in ancient times ran down to a ford over the Derwent called The Causey. It marked the earliest route to Nottingham, pre-dating the bridge. The delightful timber framed pub was the Nottingham Arms (LGII), from its name and position clearly of very ancient origin. It was unforgivably demolished in 1964 to make way for a car park, although the site was only developed in the late 1980s, with offices – except for those of architects Naylor, Sale and Widdows (*centre*) – in neo-vernacular style. *Photograph c. 1930 by Margaret Goodey.*

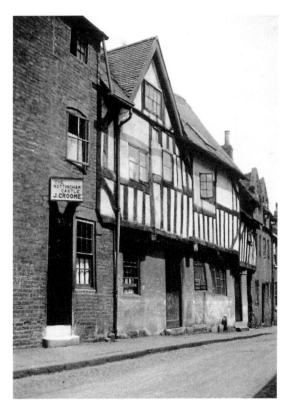

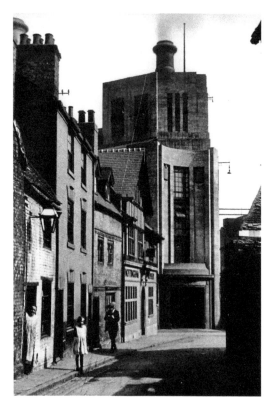

Full Street, Nanny Tag's Lane

A few yards further south from St Michael's Lane is the upper end of Full Street, anciently known as Nanny Tag's Lane, or Alderman Hill. It was widened in 1944 and formally united with Full Street, when the cottages on the left were demolished, leaving only the 1925 rebuilt Silk Mill Inn with its *faux* timbering. From the 1920s, where it turned south as Full Street, was built an Art Deco extension to the municipal power station. The power station went in 1972, to be replaced by a huge electricity substation hidden behind an unnecessarily high wall. Peeping over the top is the bell tower of the Silk Mill (George Sorocold, 1718, LGII). This was rebuilt in 1821 and again in 1910 after fire broke out. In the 1980s, a rather naïvely executed mural was painted on the blind wall of the pub, depicting the 1834 silk mill strike. It is nothing if not colourful. *Photograph by Margaret Goodey, 1930.*

The Derwent

One limpid morning in 1978, on my way to lecture at the Silk Mill, I was entranced by the view south down the river. The river was clear and unruffled, as seen here. Apart from Exeter Bridge (C. A. Clews, 1929), all is trees that almost hide C. H. Aslin's fine river façade of the 1933 magistrates' courts (LGII). Today, recent landscaping has gone to seed; the trees have been tamed and the former magistrates' courts are scaffolded and covered in plastic, ready to be converted into housing. Beyond is Aslin's monumental neo-Georgian 1938 council house (rebuilt in 2012), and beyond it the so-called Riverlights, a speculative development by a firm that went bust. The scheme was rescued at the cost of completing the over-large and ugly building cheaply, in battleship grey, divergent from that granted consent some years earlier. In short, the fine view down Derby's river has been utterly ruined.

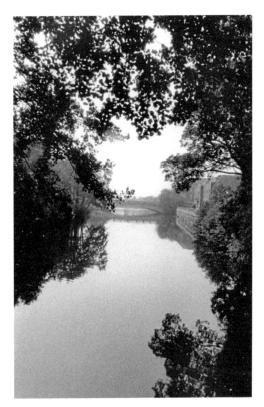

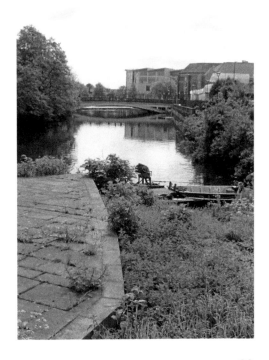

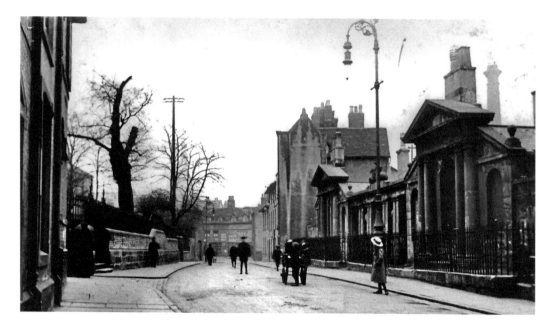

Full Street, View North

Full Street is ancient and runs parallel to the river. It was fashionable in the seventeenth century, when Bess of Hardwick endowed almshouses opposite the east end of All Saints (now the cathedral). These were rebuilt, as seen here, by Joseph Pickford in 1777. They were then demolished to make way for the municipal power station in 1894. The electrolier is one of a batch installed in 1893. The building (*far left*) is the works of John Davis & Sons, (1870), optical and mining instrument manufacturers. It is now demolished, but the firm still flourishes. The east end of the cathedral (1971) now obtrudes, the rebuilt Silk Mill Inn stands out and the windowless tower of the Jury's Inn dominates all. *Photograph by Richard Keene c. 1892, subsequently made into a postcard [Private collection].*

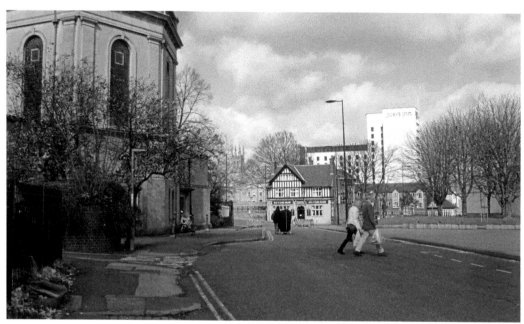

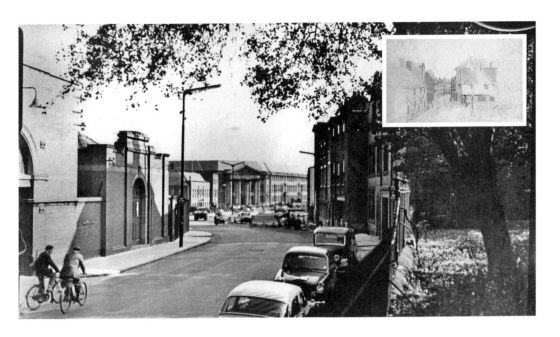

Full Street, View South

Peter Perez Burdett (1734–95) was a cartographer and artist who made the second ever 1-inch map of an English county in 1767. He lived in a Gothic house in Full Street, just visible towards the left in this important drawing he made of the street in 1765, which shows the pre-1777 Devonshire almshouses (*left*) and the fine houses swept away in 1933, when the council was intending to dual the road. Instead, they built a power station in 1894, demolished it in 1972 and then did a brave thing: they left the site green, giving the cathedral and Silk Mill room to flourish. Also in 1971, the surviving Georgian buildings on the right were removed to make way for a multi-storey car park. The elevated position of the first two views is no longer accessible.

Painting of c. 1765 by P. P. Burdett [Derby Museums Trust L551] & Photograph of October 1959 by Frank Scarratt.

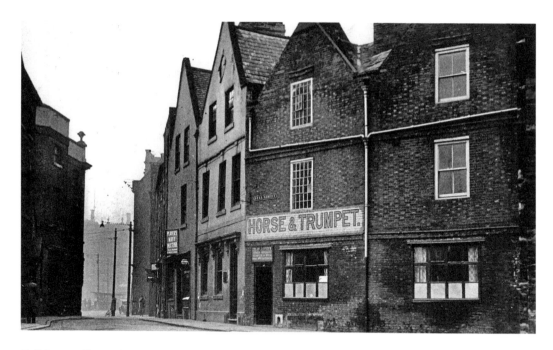

Full Street, Horse & Trumpet Inn

At its south end, Full Street turned right and fed narrowly into the marketplace. On the inside of the curve was the Horse & Trumpet Inn (1761, closed 1967), and next to it, the taller County Assembly Rooms (1713–64, later a china showroom). Opposite is the side of the later assembly rooms (*see p. 7 above*). This was all swept away in 1970/71, in order to build the current assembly rooms and attached car park. The former is currently closed as a result of a fire that happened in February 2014, in the air conditioning plant situated on top of the latter. Today, the scene is ugly and unrecognisable, although one can still reach the marketplace from Full Street – just. *Photograph by C. B. Sherwin 1926.*

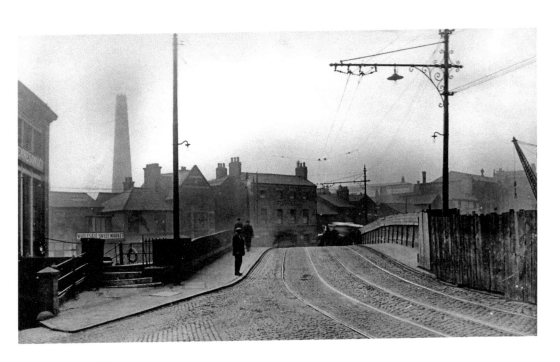

Exeter Bridge

Derwent Street leads from the east side of the market place, across the Derwent via Exeter Bridge (1850, Samuel Harpur, borough surveyor), which was named after the eighteenth-century landowner of Canary Island – the land on the river's east side, Brownlow Cecil, 8th Earl of Exeter. In 1904, it acquired tramlines, which made it hopelessly constricted, leading to the building of the present, much wider, bridge in 1929. The buildings on the far side (including the shot tower, built in 1809 and demolished in 1931) were swept away to make room for the Council House (C. H. Aslin 1938–45). *Photograph by C. B. Sherwin 1926.*

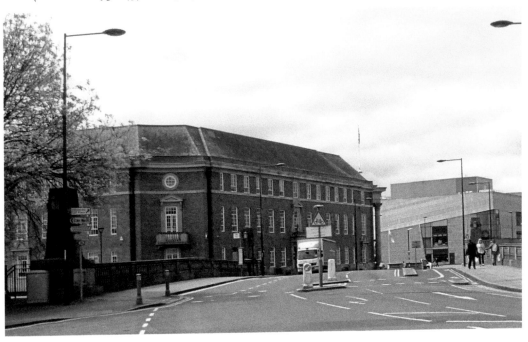

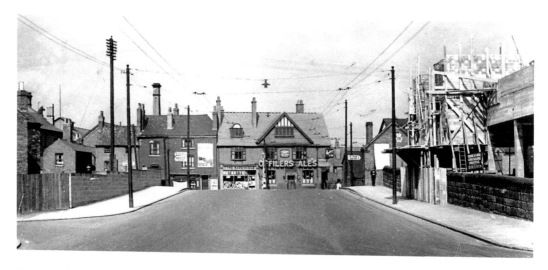

Derwent Street East

Were one to turn 180 degrees from the previous viewpoint, they would be looking down Derwent Street East, which traverses Canary Island, to the junction with Nottingham Road. The large gabled building is the Liversage Arms, centrepiece of the Liversage Estate (Alexander MacPherson, 1898–1901) – one of the manifestations of the city's oldest and richest charity. Unfortunately, in 1968–71, the new inner ring road cut through the entire area, running along the line of the former canal arm, in front of the pub and its accompanying houses on a hideous concrete viaduct. A car showroom is being built on the right (replaced in the 1970s), but the fine *Moderne* NatWest building (Naylor & Sale, 1937/38) has yet to be started on the left. *Photograph of 1935 by Frank Scarratt.*

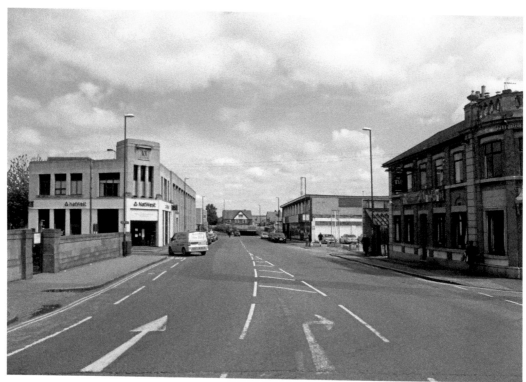

Exeter Street

The turning, middle distance (right in the previous view) is Exeter Street, on which stood this handsome row of Regency houses *c.* 1816, Exeter Terrace. At the south end, on the corner with Exeter Place, survives the Exeter Arms, which is still one of Derby's most satisfying pubs (albeit that its sign today displays the arms of the City of Exeter, not those of the Marquess, from whose ancestors' pleasure grounds the area took its name). In the house on the extreme right was born, in 1820, England's greatest philosopher, Herbert Spencer. He died in 1903, marked from 1905 by a modest stone plaque over the door. As with Spencer's childhood home in Wilmot Street, it was wantonly demolished when the inner ring road was being built. Thankfully the inn survived, and a blue plaque was put up in memory of Spencer in 2014, by the council and Civic Society.
Photograph by Frank Rodgers, 1946.

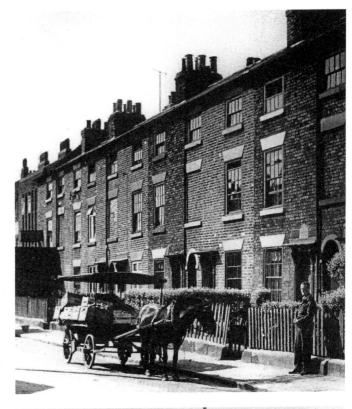

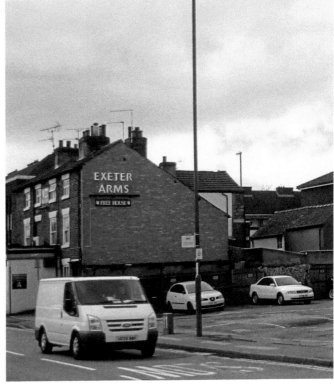

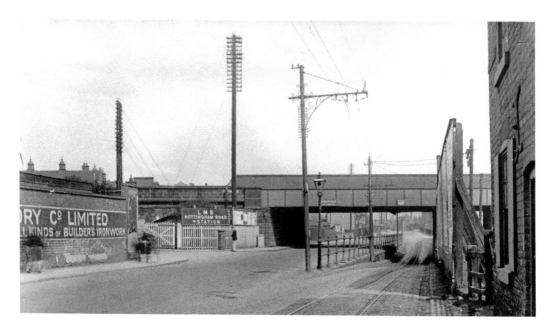

Nottingham Road

East of the Liversage Estate, Nottingham Road is crossed by the former Midland Railway main line. Since 1923 this had been known as the LMS, the initials of which are proudly displayed on the station signboard, left of the bridge, marking the entrance to Derby's second station: Derby Nottingham Road, opened in 1856 and closed in 1966. The road dipped under the bridge to accommodate double-decker horse buses and trams from 1880, although in 1898, one of the former failed to take the dip and collided with the bridge, seriously injuring numerous passengers. The dip was widened with the coming of trolleybuses in 1934; the station was later closed, but the scene is otherwise little changed. *Photograph of June 1932 probably by C. B. Sherwin; modern picture, June 2014.*

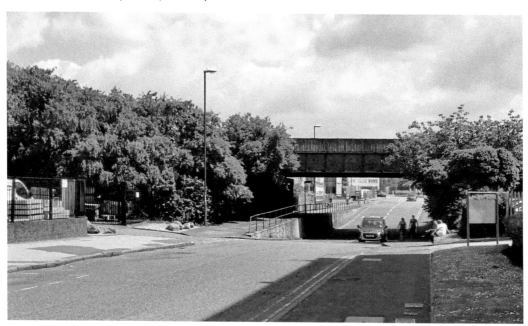

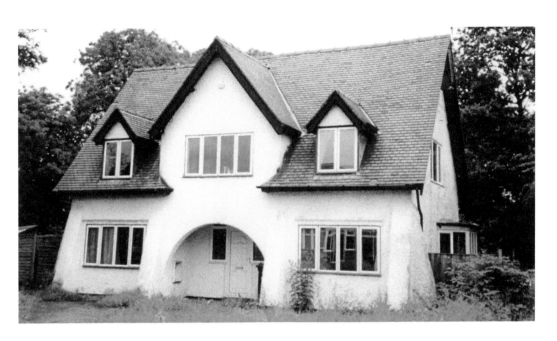

Chaddeden, The Cheese House

A mile further along Nottingham Road and one reaches the suburb of Chaddesden. In 1937, the Kraft Cheese Co. offered a prize competition, the winner of which would be given an architect-designed house near where they lived. The winner was a Derby man and, at No. 57 Lime Grove, this attractive house, ever afterwards known locally as the Cheese House, was built for the fortunate winner (whose name has entirely eluded research, as has that of the architect). In 2006, this delightful building was demolished, so that a developer could build six small formulaic dwellings on Messrs Kraft's generous quarter of an acre of grounds. The house could so easily have been retained, even at the cost of slightly fewer new ones. At least the new close was named Kraft Gardens. *Photograph by the author July 2005.*

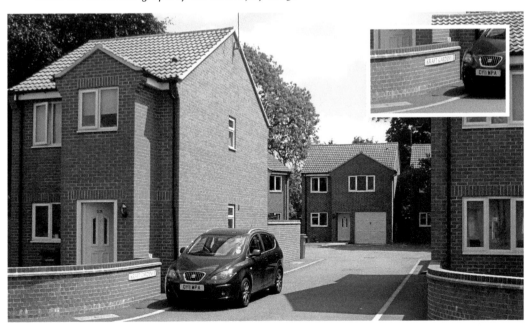

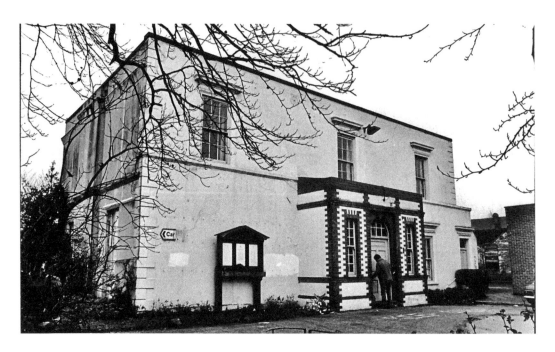

Spondon Old Hall

A further mile or two east of Chaddesden lies Spondon, added to Derby in 1968. In its declining years, Spondon Old Hall was a sorry sight. An old rambling house of the Coke family of Brookhill and Trusley (acquired from the Wilmots of Chaddesden), it had been drastically reduced in size between 1846 and 1851, in order to resemble a compact, mildly Italianate three-storey villa. It was here that Selina Sitwell was long a tenant, hence Sitwell Street, in which it stands. The Cokes sold it in 1891, and the local authority removed the top floor (clumsily), opening it as a library and community centre in 1957. The city council, however, replaced it with a new building in 1977. *Photograph of 1976* [Derby Telegraph].

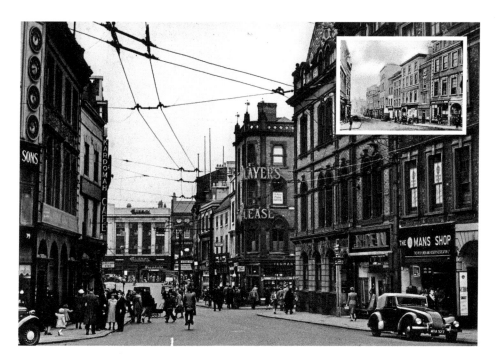

Corn Market

Returning to the Market Place, the ancient north–south route through Derby proceeds south via Corn Market, seen from here in three eras. In the 1860s, a consortium widened St James's Lane (*opening, centre*), knocking down all the buildings from the right-hand side to the Gothic four-storey one in the more recent views. Their architect was the prolific George Henry Sheffield (1843–82). The glass building now on the left was built as Williams & Glyn's Bank in 1973, replacing John Smith & Sons' clock shop, with its four clock dials showing times around the world. Trams and trolleybuses have come and gone (1880–1934, 1932–1967), not to mention the superb Allard; the street was pedestrianised in 1990. *Photographs by Richard Keene of May 1855* (inset) *and Frank Scarratt of 1949.*

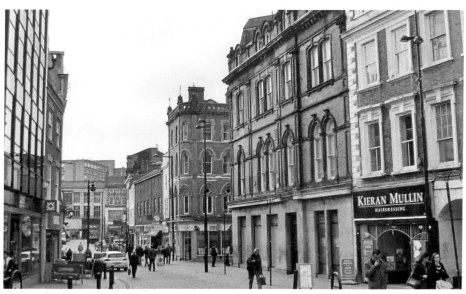

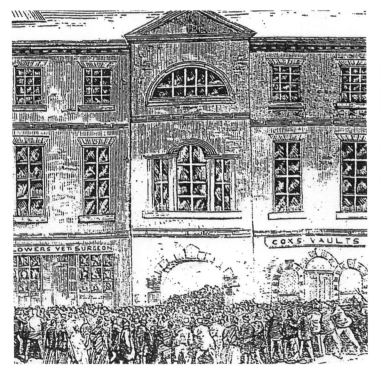

Cornmarket, The Tiger

Opposite the end of St James's Street (formerly Lane) stands a once-fine Palladian building, attributed to Joseph Pickford and built in 1764 (LGII), for Sir Willoughby Aston, 5th Bt. MP (Nottingham). His family had inherited the previous house, along with the Risley Hall Estate from the Willoughbys. In 1770, he let it out; it was converted into a coaching inn called The Tiger, which continued until 1815, at which time it moved to a building in the yard behind, and the premises remained, let as shops. At some stage prior to 1866, the balls were removed from the parapet; later, the pediment was altered and stuccoed, three windows being inserted on the right side of the first floor. In the nineteenth century, the police lock-up lay behind the building through the arch, still called Lock-up Yard, but previously Tiger Yard. *Wood engraving from the* Police Gazette, *1866 [DLSL].*

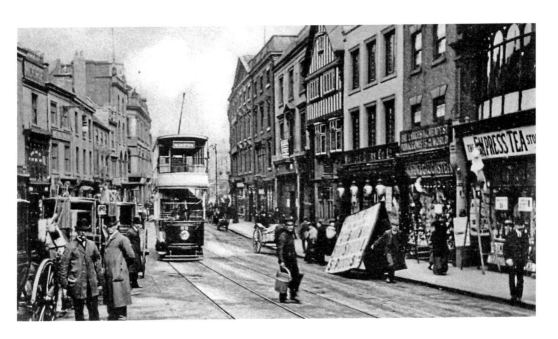

Corn Market, St Peter's Bridge

The southern end of Corn Market once crossed the Markeaton Brook on a bridge called St Peter's, or Gaol Bridge, which was culverted in 1848; it still lurks beneath the road surface. The wide street, here until 1863, accommodated the grain market area and was lined with pubs, none of which survive today. Until 1836, the Tudor Borough Gaol stood by the brook, and one crossed to the bridge under an arch. This was commemorated in 1990 by an iron *serliana* when the street was pedestrianized, but for unknown reasons was quietly removed when a further 'improvement' was made, ironically called Connecting Derby, in 2004. There was no sign of conservation area consent for its removal either. What happened to it? *Photograph from an anonymous postcard postmarked 1907; 1991* [Derby Telegraph].

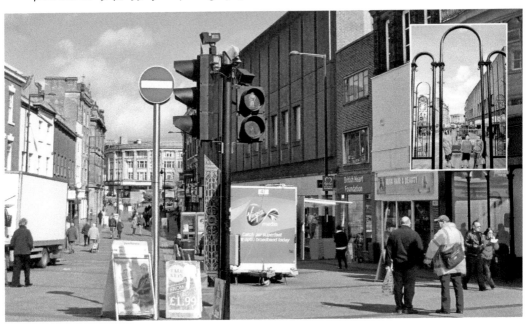

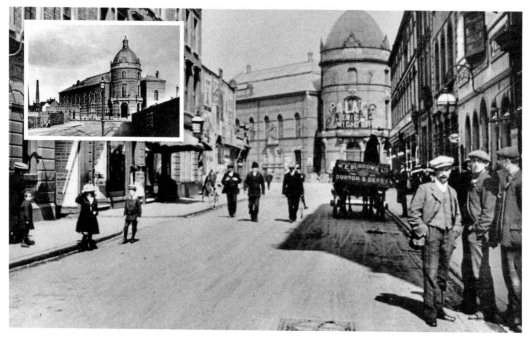

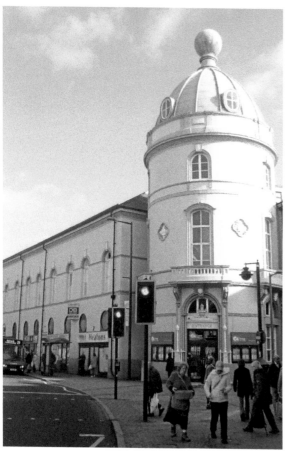

Albert Street, Corn Exchange

The 1860s saw a municipal burst of tidy-mindedness, with an attempt to get the three markets: beast, corn and general, off the streets and under cover. Hence the Corn Exchange (Benjamin Wilson, 1861/62, LGII) in newly pitched Albert Street (1848). Hardly inspired architecturally, it had coloured-brick banding, a windowless ground floor, a huge ornamental drinking fountain and decorative cresting. It failed to pay its way and was soon converted to a variety theatre and then in 1921 to a Palais de Danse by W. Champneys, who stuccoed over the decorative brickwork. Grey Wornum designed a stunning and avant-garde interior scheme. In 1928, the *Derby Daily Telegraph* took it over, put in ground floor windows and printed their papers there for nearly sixty years. Today it is offices with its original staircase and cresting removed, and an extra storey in the dome. *Photograph by C. B. Keene of c. 1900 [Derby Museums Trust] and (inset) by Richard Keene in 1863.*

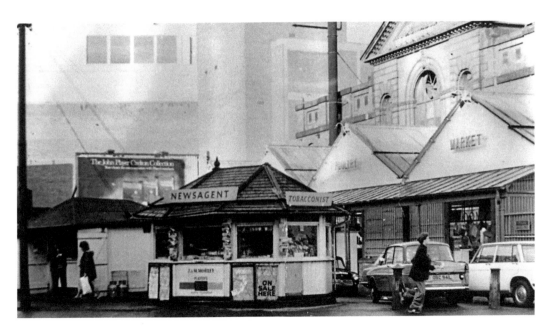

Albert Street, Osnabrück Square

The Market Hall (1864/65, Robert Thorburn and Edwin Thomson, LGII) was created in the same spirit as the Corn Exchange and its south end, Mill Ground, looked over Albert Street (created by culverting the brook in 1848). In 1929, it was extended to include a fish market, and some shacks serving snacks, newspapers, etc., appeared in front on Mill Ground. When the fish market was moved in 1984, the shacks, which included a redundant cabbies' rest (*foreground*), were swept away to be replaced by brick imitations. The area was renamed Osnabrück Square, in honour of Derby's German twin city. Attempts to save the cabbies' rest for the museum were rebuffed. *Photograph by Raymond's Agency for the* Derby Trader *1973* [*Derby Museums Trust*].

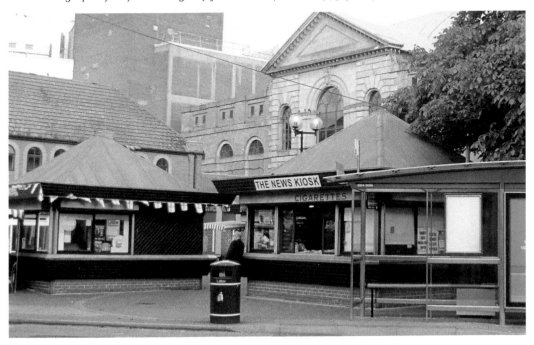

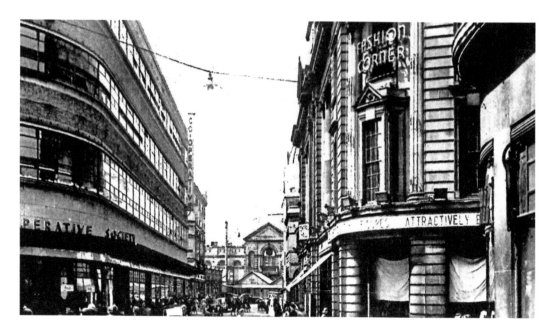

Exchange Street, The Derby Co-op

Standing in East Street looking down Exchange Street, towards Albert Street, one is claustrophobically hemmed in by large buildings. This is where the Derby Co-op, England's third such, founded in 1850, had their stores concentrated. On the right is a block of 1913 (Alexander MacPherson) still fulfilling the role for which it was designed. On the left, a remarkably eye-catching *Moderne* store, designed in 1939 by Sydney Bailey after Bruno Paul's Sinn department store of 1928 in Gelsenkirchen, Germany. Work stopped in 1940, only to be resumed in 1949, and was completed in 1953. An attempt to list it failed in 2012 when the Co-op closed it, but it has since, mercifully, found a new occupant. *Photograph by the Cooperative Society from David Boydell*, Centenary Story *(Manchester 1950).*

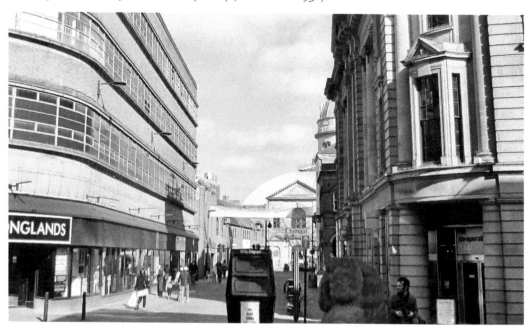

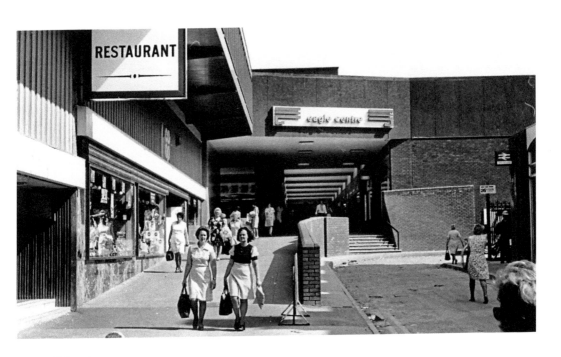

Albion Street

Albion Street is opposite the end of Exchange Street, and once defined part of the bailey of an adulterine castle from the Anarchy period, 1135–54. By the early nineteenth century, it led to a complex pattern of mean streets and early terraced housing. This was all swept away in 1969–72, to build a shopping complex of unmitigated awfulness called the Eagle Centre, seen here. In the first decade of the twenty-first century this too was swept away, and replaced by Westfield, which opened in 2008, drawing yet more shopping away from the historic heart of the city. It is now called the Intu Centre. The street itself has been much improved by good quality new build. *Photograph of 1974 by Raymond's Agency for the* Derby Trader [*Derby Museums Trust*].

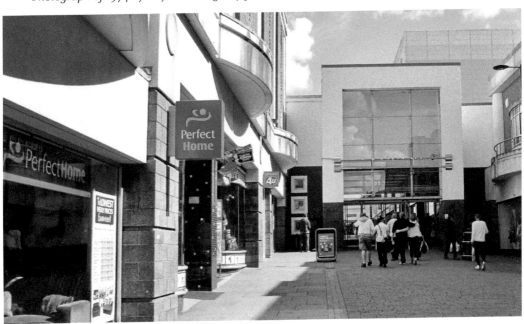

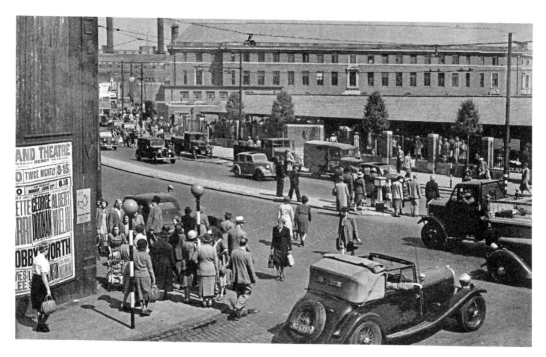

The Morledge

Morledge is another ancient thoroughfare, dualled for the Central Improvement Scheme in 1935. The scheme also provided for the council house (*background*), open market (C. H. Aslin, 1933) and envisaged much more but for the Second World War. The view is from the end of East Street, now pedestrianised, whilst the open market was swept away for new crown court in 1988, which entirely hides the south front of the council house. Note the Municipal Power Station, Full Street (*rear left*) in all its ugly glory. *Photograph by Frank Scarratt c. 1946.*

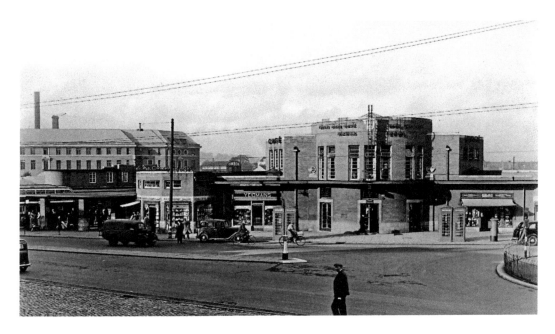

The Morledge, the 'Bus Station

As part of the central improvement scheme of 1932 onwards, a somewhat restricted site south of the Open Market was reserved for a new 'bus station. This was designed with parabolically planned platforms to fit the site by Herbert Aslin and opened in 1933. It had an Art Deco rotunda nearest the Morledge, seen here, containing a restaurant and ticket office with a matching block behind with administrative offices. Latterly, it all became very run down but was listable and capable of effective refurbishment, but the scheme that produced the so-called Riverlights development wanted the site, so promised a new 'bus station. What we actually got, after a bankruptcy and years with no 'bus station at all, deviated from the approved plan, is ecologically disastrous and inconvenient to use. Its grey metallic elevations are indescribably dreary and cheap-looking. *Photograph of 1939, photographer unknown, possibly Scarratt [Private collection].*

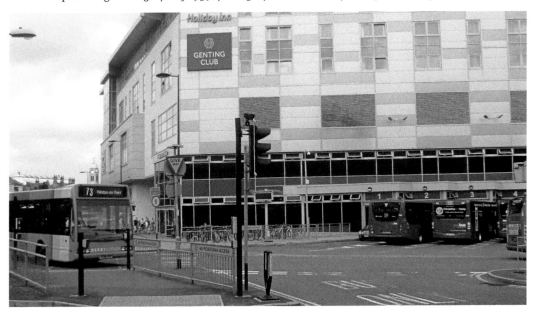

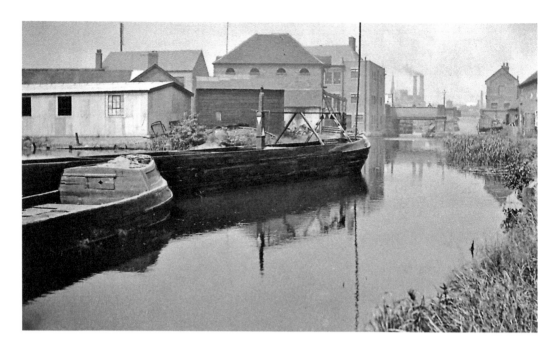

Cockpit Hill: Canal Basin

Absolutely nothing in the inter-war scene has survived the planning that befell the area after the canal was officially abandoned in 1964. Left of centre is the fine Bridgewater Warehouse (dated 1820, LGII), with its row of four thermal windows; it was mercilessly destroyed in 1975. The canal was filled in eventually to build station approach and the accompanying flyover, which was built (to the detriment of the railway conservation area) to give access to Pride Park in the early 1990s. In the older view, note the twin chimneys of the Full Street power station; in the lower, its equal in ugliness: the Cockpit Hill car park. *Photograph by Margaret Goodey, 1930 [Mrs. P. Cannon].*

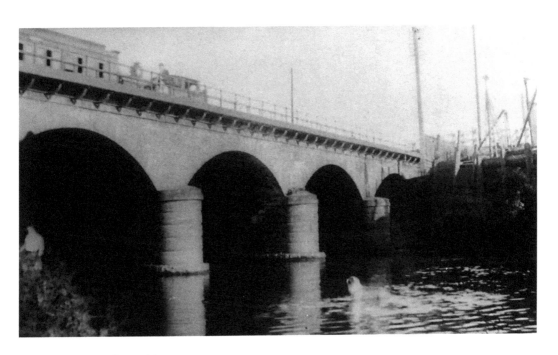

The Five Arches Bridge

When the North Midland Railway was being built in 1839/40, Robert Stephenson was the engineer, aided by Frederick Swanwick, who acted as executant architect. The bridge, seen here, immediately north of the Trijunct station at Derby, had five arches, from which it derives its name. It is seen here being crossed by a Midland Railway 1200 class 0–4–4WT going bunker first into the station at the head of empty stock. The bridge (LGII) survives, but access to the same position is today impossible. The train has changed a bit too. *Photograph by Frank Scarratt c. 1913.*

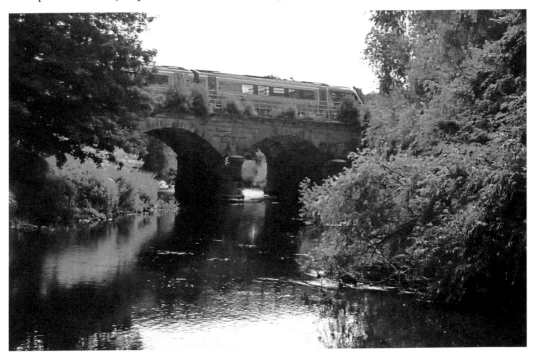

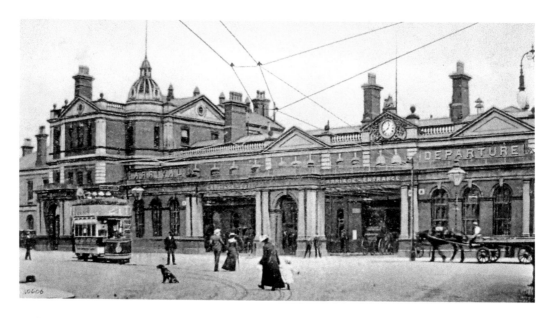

Railway Terrace, Derby Midland Station

Derby Trijunct station was so called because three railway companies originally shared one very long platform. It was designed in fine Classical Revival style by Francis Thompson. The Midland Railway took over in 1844, and by the time the photograph was taken, it had acquired two lots of accretions, although the original station lay intact beneath them all. The horse tram suggests a date around 1898. Around 1980, so the story goes, Sir Peter Parker, then head of the nationalised railway, was conducting a Chinese delegation to see the locomotive works, and was horrified at the dinginess of the station. He ordered its immediate replacement. SAVE Britain's Heritage and Derby Civic Society's efforts to save it were entirely in vain; the old station was duly pulled down and replaced by one designed by the late Bernard Caucas, which was rightly condemned by Professor Gavin Stamp as a 'high-tech shack'. It leaves much to be desired. *Photograph from a postcard [Private collection].*

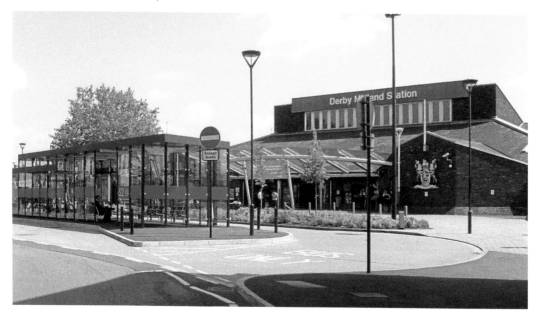

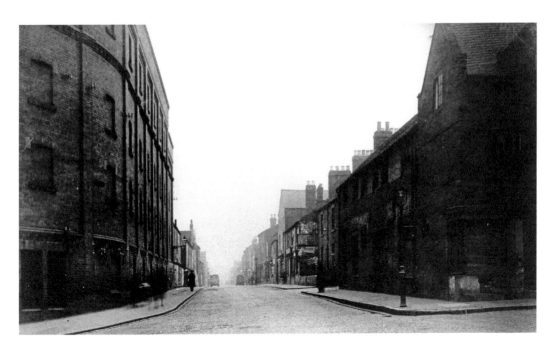

Siddalls Road

Between the town and the new railway station lay an area of water meadows called The Siddalls, crossed by Siddall's Lane. The coming of the railway turned it into a major route into town; within three decades it was lined by terraces of artisans' cottages. Here we see the town end, as it was crossed by Traffic Street. On the left, the enormous bulk of Sir Alfred Haslam's ice factory (built *c*. 1888, demolished 1984) and the house on the right, was built in 1750 for William Butts, co-proprietor and potter of the newly founded Cockpit Hill Pottery. It went for road improvements in 1937. Today, only the course of the road remains and the trees are illusory, for beyond lies a vast development site. *Photograph of 14 January 1937 by Hurst & Wallace [Graham Penny].*

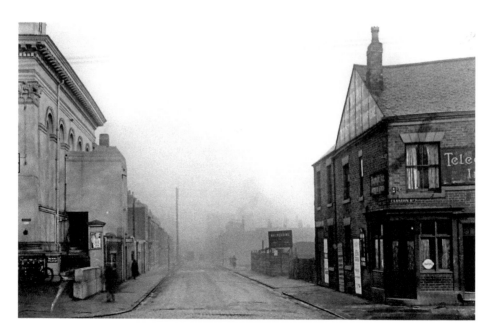

Traffic Street

Originally, Traffic Street was a narrow, terrace-lined street, running at a right angle from London Road to Siddall's Road, pitched over the grounds of Castlefields House by 1826. At the London Road end, it was flanked by the impressive Classical Congregational chapel (Henry Isaac Stevens, 1846, demolished 1964), and a modest beerhouse of 1823 – the *Royal Telegraph*, named after the London–Manchester mail coach. Then, in 1937, as part of the Central Improvement Scheme, the council turned the street into a dual carriageway and realigned it. The pub was replaced on more ambitious lines (Browning & Hayes, reopened 17 March 1937), but the chapel (by then a cinema) succumbed to further road improvements in 1964, and the site was swarmed over by the Marks & Spencer element of the Westfield (now Intu) shopping centre in 2008. *Photographs taken on 14 January 1937 and 3 March 1938 by Hurst & Wallis [Graham Penny].*

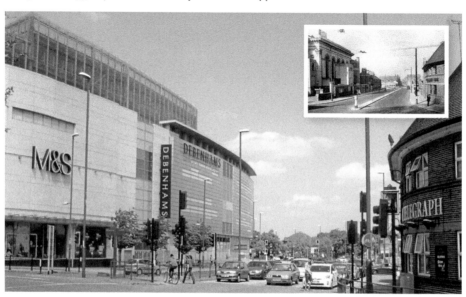

London Road, a Railway Church

As the Midland Railway village expanded south and west of the station, facilities of all kinds were needed. Nor did the spiritual needs of the workforce become neglected, as testified by the magnificent church of St Andrew, London Road (Sir Gilbert Scott 1869 LGII). This was paid for by Revd John Erskine Clarke and Charles Borough of Chetwynd Park Salop, along with parsonage and schools, also by Scott. The first head of the school was George Sutherland, grandfather of the artist Graham Sutherland.OM RA (1905–80). The church, its spire a notable landmark, was declared redundant and demolished in 1970, to allow the building of a bland office block for the Ministry of Pensions. Here we see the view from Bloomfield Street, with Regency Litchurch Villa on the left. The street is now a 100-yard long car-choked access to a medical facility. *Photograph by Richard Keene c. 1890.*

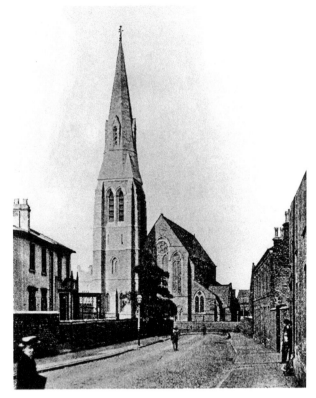

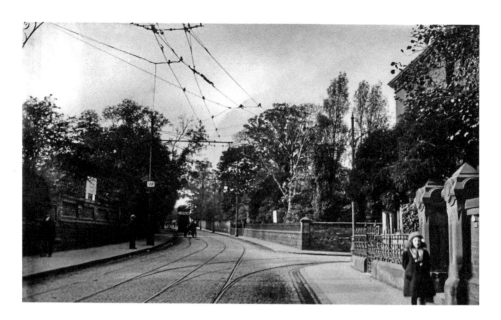

Osmaston Road, the Mayors' Nest

From Bloomfield Street, one once could make one's way to Osmaston Road at one time. Almost parallel to London Road, it was lined with impressive villas built between 1823 and the 1870s, at one time almost all owned by Borough Aldermen, and known locally as the Mayors' Nest. Here we are looking back towards Derby, near the corner of Bateman Street. The large villa (*right*) was Ivy House, then the home and surgery of Alderman Dr Laurie (later mayor), demolished in the 1920s to build Ivy Square: a neat enclave of municipal housing. Hidden behind it is Litchurch Villa (just in vision in the modern view), built in the 1820s for the Bateman family of Hartington Hall, and from 1886 home to town clerk George Trevelyan Lee. In the 1920s it became the Rolls Royce Foremen's Club, a purpose that it still serves. Today, the west side of the road (*left*) has been dualled and the villas have become plush trade union social clubs and the likes. *Postcard postmarked 1909.*

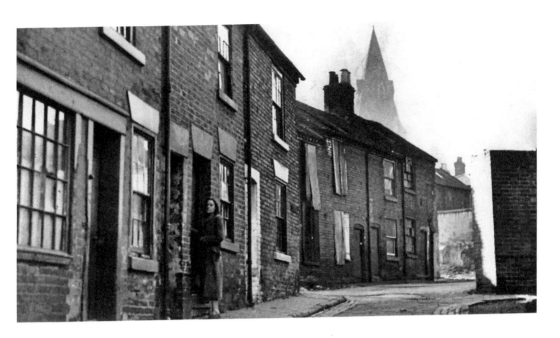

Upper Hill Street

East of Osmaston Road, from 1760, a number of short, mean streets leading towards London Road were pitched on what had been High Park Corner – the edge of the parkland of Castlefields House. Here we see Upper Hill Street, which in the eighteenth century had been called (no doubt for perfectly logical reasons) Cuckolds' Alley. The workshop on the left was long that of clockmaker Peter Brownsword (1773–1844), whose sister became the mother of turret clockmaker John Smith (1813–83), Brownsword's apprentice. The area was cleared to create Bradshaw Way in 1964, and largely covered with huge prefabricated metal clad retail outlets in the early 1980s. Only a stub of the street remains, part of a car park. The Baptist chapel (by T. C. Hine of Nottingham, marked by the spire) was replaced in the 1960s by a lower structure. *Photograph taken for the Council by Hurst & Wallis c. 1947 [Derby Museums Trust, L8609].*

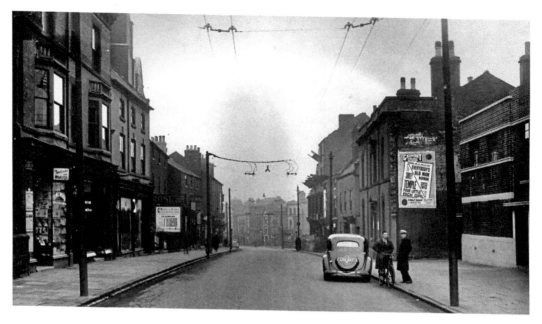

Osmaston Road

Osmaston Road constitutes the southern part of what was a prehistoric trackway from Swarkestone Bridge (anciently an artificial causeway), which ran through the future site of Derby, up the ridge and on up the Derwent Valley. The Romans retained it, and in the tenth century Derby was founded on its course. Here we see it as it arrives from the south at The Spot, where the much later London Road joined it (*see p. 51*). On the right, a brand-new modern building (Elliott & Crookes, sports outfitters) and beyond it, an engaging agglomeration of eighteenth- and early nineteenth-century buildings in the process of being swept away to make way for major re-development. At the Gaumont Cinema nearby, the poster proclaims that Shirley Temple was appearing in *Poor Little Rich Girl*: what larks! *Photograph by Hurst & Wallis for Derby Borough Council 14 January 1937 [Graham Penny].*

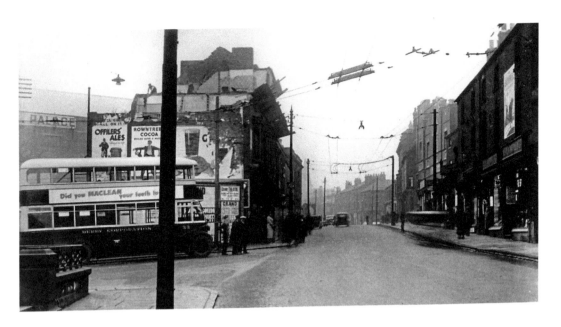

The Spot

The junction, created in the earlier eighteenth century (where London Road diverges from Osmaston Road), was first called The Spot in advertisements put out in summer 1741. They were distributed by maltster Abraham Ward, whose premises lay on the inside of the corner of The Spot. It was probably his building that had just been demolished here. The replacement structure by Sir Thomas Bennett was *moderne* and curves round the angle well. Standing in front of the works is the unique 1929 six-wheeled, petrol engine Sunbeam Sikh demonstrator No. 44, which was acquired in 1933 and withdrawn in 1940. To the far left, we see the public lavatories just opened underground, displacing a fine 1906 statue of Queen Victori by C. B. Birch, which was too heavy for them and had to be banished to the grounds of the DRI. In 1990, the top of the loos was embellished by a *faux* Art Deco clock installation (known locally as the 'gun emplacement'), by Smith of Derby, playing recorded and amplified tunes on the hour. *Photograph of 14 January 1937 by Hurst & Wallis for the Borough Council [Derby Museums Trust].*

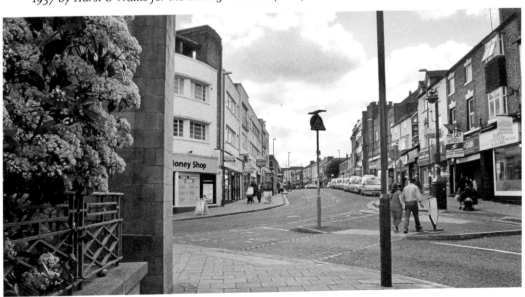

St Peter's Street

The prehistoric trackway through Derby continues north from The Spot with St Peter's Street, named after the city's surviving original church with medieval fabric, halfway down on the left. There has been a great deal of piecemeal rebuilding to both sides during the twentieth century, most of it of poor quality. Losses have included the eighteenth-century house occupied by George Simon Smith, eldest son of John Smith, a clockmaker (*see above, Nos 12 and 44*) who left the family firm in high dudgeon and set up on his own after seeing two of his younger brothers favoured over him. In the middle distance on the right, note the horseshoe above the entrance to the Midland Drapery, set up to 'draw in' eager customers. The picture pre-dates the 1904 electrification of the tramways. *Photograph from a colour printed postcard, postmarked 1905.*

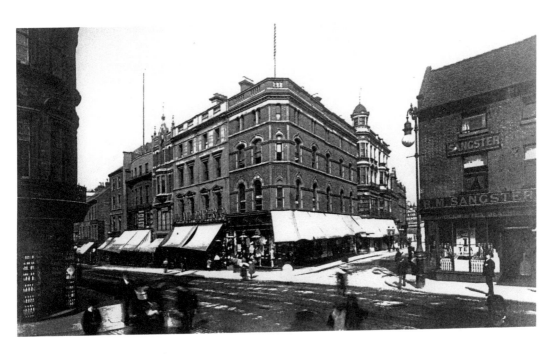

St Peter's Church Yard

Half way down St Peter's Street, East Street (*centre-right*) and St Peter's churchyard, a crossroads is formed. The council are currently putting money into the creation of 'St Peter's Cross', in order to enhance the pedestrianised intersection. In the older view, the Midland Drapery has been epically enlarged, but East Street has yet to be widened (this happened in 1911/12). The eighteenth-century building (*right*) has been replaced by a branch of Boots. The great store closed in 1969, and was demolished to be replaced by the Audley Centre, a bland two-storey brick shopping arcade of dubious fiscal viability. *Photograph of c. 1900, possibly by Frank Scarratt.*

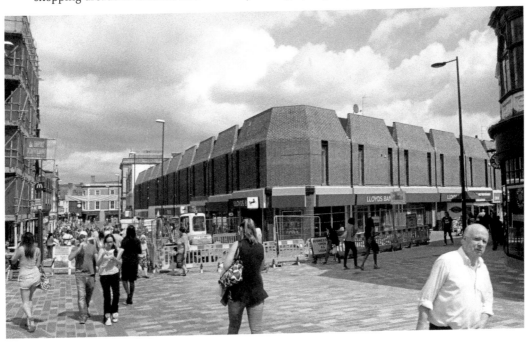

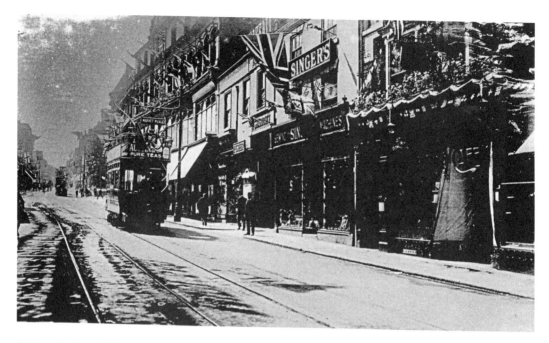

St Peter's Street, Thurman & Malin *en fête*

The view up St Peter's Street, probably during the 1911 Coronation celebrations, shows a decorated tramcar descending past Messrs Thurman & Malin's large drapery store, opposite and in competition with the Midland Drapery. Between it and Singer's was a building that gave through to Oakes's Yard where Robert Bakewell, England's greatest native-born ironsmith, had his works from 1712–52. It was replaced by the equally inconsequential gabled Yorkshire Bank in 1979. Unlike the Midland Drapery though, Thurman & Malin was converted for other uses when it eventually closed. The street was pedestrianized in 1990, as part of the Derby Promenade. *Print from an anonymous half-plate glass negative of 1911* [*Private collection*].

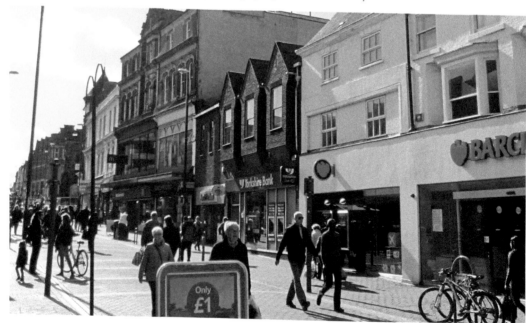

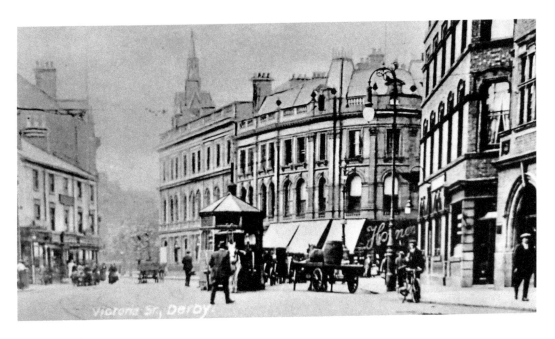

Victoria Street

Originally, at the lower north end of St. Peter's Street ran the Markeaton Brook, which one crossed on the Gaol (or St Peter's) Bridge. In 1839, this was lost beneath a culverted western portion of the brook, becoming Victoria Street, whereas it had previously been Brookside (essentially a path which ran alongside the brook, rather like Spalding or Wisbech, and was lined with fine eighteenth-century houses). On the north side of Victoria Street was built the Royal Hotel (*see dust wrapper*) and the Athanaeum Club. In 1904, the Arts and Crafts Tramways' Offices (John Ward, LGII) were added, just visible to the right, and the Spotted Horse Hotel (later the post office) beyond that, founded in 1842 and rebuilt, as here, in 1872. The buildings in the centre date back to 1873 and are by Giles & Brookhouse (LGII). Note the cabbies' rest (*cf. see p. 37*). The street is now for 'buses and cabs only. *Photograph of 1905, from a postcard [Private collection].*

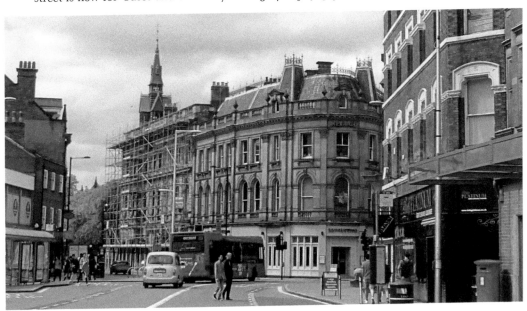

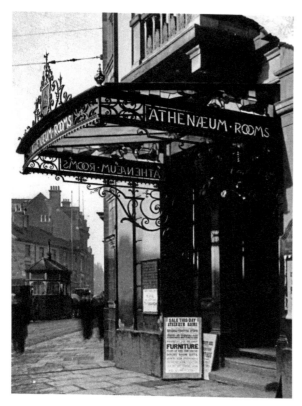

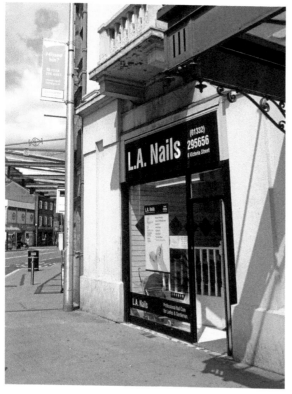

Victoria Street, the Athenaeum
The craftsmanship of Robert Bakewell was continued after his death by his foreman, Benjamin Yates, and then his son, William. The art was revived, in the teeth of competition from a vigorous cast-iron industry, in the 1850s by Alderman William Haslam, who was succeeded by his gifted son, Edwin. Edwin worked in Art and Crafts mode and exported his superb handiwork all over the country and empire. The Athenaeum (Robert Wallace of London, 1839, LGII) was later provided by him with a superb wrought-iron canopy over its entrance, as seen here. He also made similar ones for the whole façade, including the Royal Hotel. Today it has been moved, and only the brackets partly survive after drastic modification in the 1940s. The entrance is now a nail parlour. *Photograph taken by Edwin Haslam, when new, c. 1910 [Derby Museums Trust L1265].*

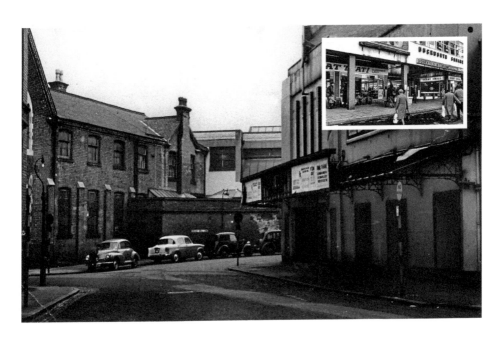

Becket Well Lane

In the early nineteenth century, land behind the south side of Victoria Street was developed haphazardly into a network of narrow cobbled streets that soon became a slum. The Medieval Becket Well (called after a *bouget*, or leather water bucket) was isolated in the garden of one cottage. In 1910, the Victoria Electric Theatre cinema opened behind the Presbyterian chapel on Victoria Street, and continued until 1962, when it was swept away for a shopping precinct called Duckworth Square (after the long-standing proprietor of the cinema). On the site of the cinema, there is an entrance to a pub called The Merlin, later the Black Prince. The development failed and all was closed by 1988. The site is now completely derelict and hamstrung by divided ownership. *Cinema photograph of 1959 and the pub from 1973 [Derby Museums Trust, former L11234].*

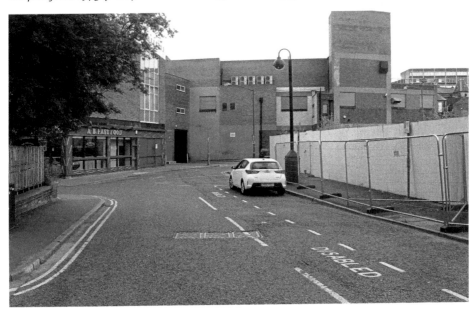

Summer Hill

Beyond Becket Well Lane and stretching up to Macklin Street (formerly Cross Lanes) were Colyear Street (still extant) and Summer Hill, later Summer Hill Yard – an atrocious slum, which came out on Macklin Street opposite the Hippodrome Theatre. It was cobbled, appallingly narrow and led down to Becket Well Lane and the vast bulk of the Presbyterian chapel (the third of the site, Hine and Evans of Nottingham, 1863, demolished 1964), which can be seen with a spindly telegraph pole competing with the spire. The area was cleared from 1962, but Summer Hill itself has been a car park ever since, only a pair of bollards marking its upper end. *Photograph from c. 1932 probably by Frank Scarratt.*

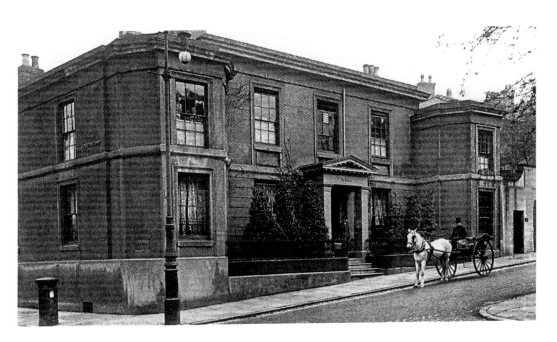

Green Lane, Green Hill House

The middle part of Green Lane, near Summer Hill, was called Green Hill. On the east side, in complete contrast, stood Green Hill House: a stylish Regency villa built for high-flying lawyer Charles Clarke in 1825, probably to the designs of Derby amateur Alderman Richard Leaper (1759–1838). The property was later the home of opulent currier John Richardson of W. & J. Richardson, St Peter's Street, and in 1891, was acquired by memorable GP Dr George Sims. Here we see his gig awaiting him outside the house in Edwardian times. On his death in 1925, it was rapidly destroyed to build a bland row of shops designed in unimaginative neo-vernacular by John Wills Jnr, whose offices were in St Peter's churchyard opposite. *Photograph of c. 1899/1904 [Private collection]*.

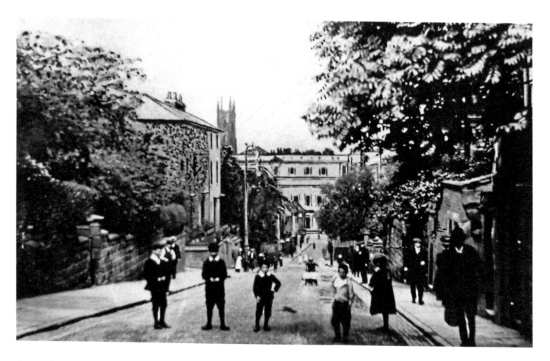

Green Lane

One hundred yards further up Green Lane and in the same era as the previous view, we find a group of children, (who are well-to-do, judging by their Eton collars) posing in the road. This is a fine view down to the façade of the Athenaeum, with the cathedral tower beyond. The short terrace of three tall Regency houses on the left has gone to seed badly over the past century. Today, the tower of the Jury's Inn lurks behind the cathedral, and a seven-storey office block was built on the Gower Street corner in the 1970s. *Postcard from a Nottingham issuer postmarked 1906 [Private collection]*.

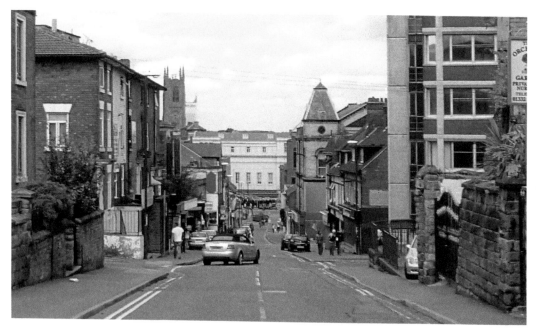

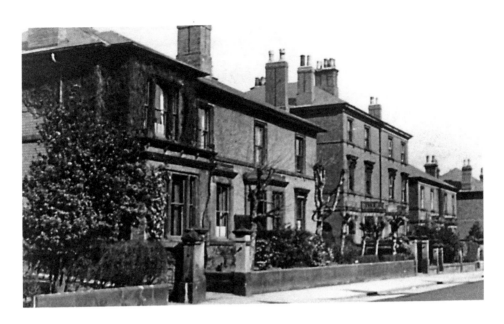

Wilson Street

The street, like most west of Green Lane, was named after Wilson Macklin, a member of an Irish landed family, who owned the land here in the mid-nineteenth century. The street was pitched in 1849 and lined with large and middling houses. The 1850s house nearest the left was home to the Lambs, draper from the 1870s to the 1890s, but by 1898, it was the home and surgery of Dr W. H. Mackay. In 1936, it was shared as a surgery by Dr George Russell (physician) and Stuart Revels (surgeon). The author was invited to join the present practice by Dr Alan Hough, the senior partner in the 1990s. Although Green Lane was recently made a conservation area, it was too late for these houses, which have acquired unsuitable (and ecologically unsustainable) plastic windows, lost their parapets from their bays and been shorn of their chimneys. *Photograph of 1948 [Derby Museums Trust L5889].*

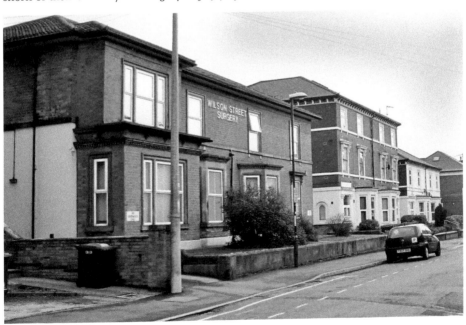

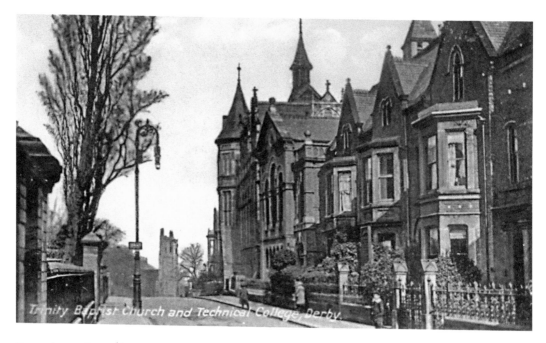

Green Lane, the Derby Art College

The three towers visible in both these views are all part of the Derby Art College (LGII*), built to the designs of Frederick Waller of Cheltenham (T. H. Huxley's son-in-law) in 1876/77. They were expanded by him, as a close friend of the first principal, Thomas Simmonds, to take in the Municipal Technical College. It became part of Derby University in the 1990s, but was closed and abandoned for some years before undergoing a modest revival. Next to it is the Trinity Baptist chapel (Lawrence Bright of Nottingham 1881), and the villas near the camera, Lenham Parade were built on the grounds of his house, Abbott's Hill in the 1890s by W. H. Richardson, currier nephew of the owner of Green Hill House (No. 53). All their ornamental cast-iron palisading was sacrificed to the war effort in 1942. *Photograph from a colour lithographic postcard.*

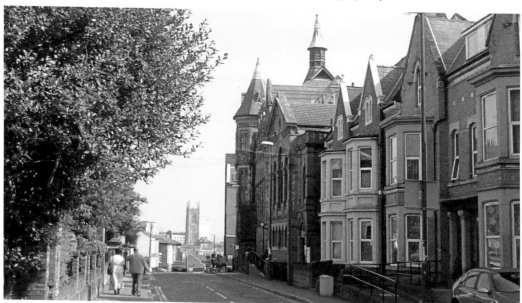

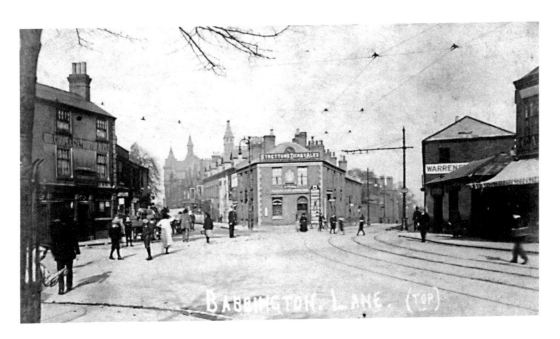

Green Lane, Babington Arms

Where Green Lane met Burton Road, and continued onto Normanton Road, Babington Lane also formed a junction (seen here with a tram emerging from it in front of the pub on the angle with Green Lane). Called the Babington Arms, it was established in the early nineteenth century and named after the Babingtons of Dethick, who had their townhouse lower down, where Mary, Queen of Scots spent one night on 15 January 1585 – a year before its owner's plot led both to their doom. The pub closed in 1926 and was demolished to improve the junction, but the plot is still empty. In 2009, the junction was completely rebuilt to accommodate the new Derby inner ring road, here called Lara Croft Way after a virtual person invented by a local firm. The general clearance leaves a good view of the Municipal Technical College extension of the Art College. *Photograph of c. 1907 from a postcard by J. S. Simnett [Private collection].*

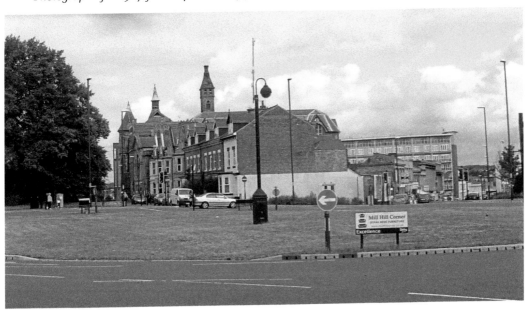

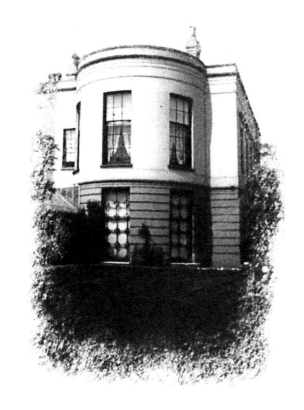

Mill Hill House

Just up Mill Hill Lane, off Normanton Road, lay this extraordinary Regency Greek revival villa. Alderman Richard Leaper designed it for his cousin Thomas Ward Swinburne, around 1811, under the influence of Sir William Gell (who was then helping his friend Sir Charles Middleton to build 'the perfect Greek house' at Belsay, Northumberland). The first floor saloon, lit by this curved bay, was a sublime room with magnificent views over the 25-acre park towards Normanton – until the next owner sold land for the construction of a lead works. From then on it was all downhill, and the mansion lost its service wing in 1936; after an attempt to get it listed failed, it was unceremoniously demolished in February 2006. *Photograph c. 1890 by a member of the Renals family, and one by the author of August 2005 [Private collection].*

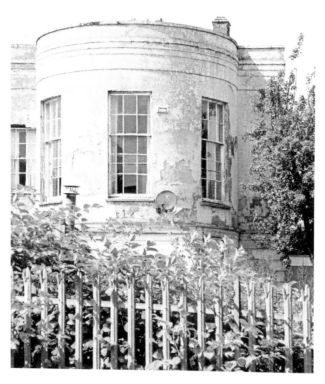

64

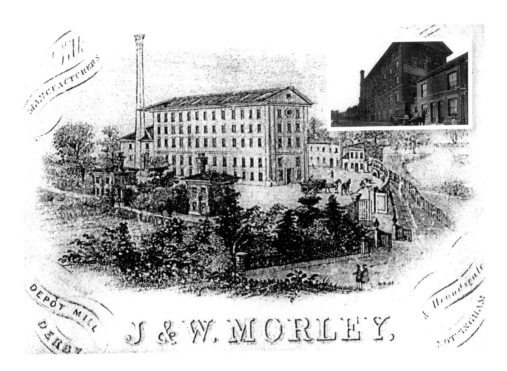

The Ordnance Depot

A little further along Normanton Road from Mill Hill Lane, the Ordnance Depot was built in 1805 by James Wyatt. It was decommissioned in the 1820s and sold to Ambrose Moore, who turned it into a silk mill, building streets of workers' houses along either side of it. They were named Ambrose and Moore Streets, which gesture failed to save him from bankruptcy. It then became Morley's lace mill and thereafter the warehouse of the Star Tea Co., before being purchased in 1884 and radically rebuilt as a brewery by William Bradford for George Offiler. This was demolished by Bass in 1966, and the site became a particularly unlovely supermarket, with precious little of the two flanking streets suffered to remain. *Engraving, Morley's advertisement 1852 and photograph by W. W. Winter c. 1875 [M. Craven & W. W. Winter Ltd.].*

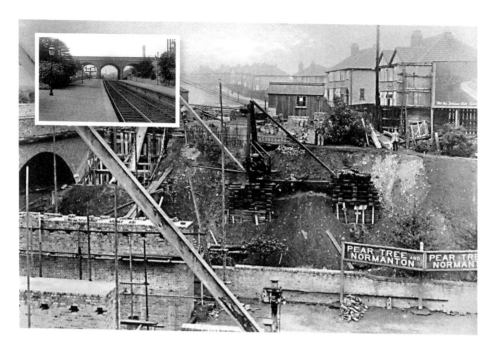

Normanton, Peartree Station

The railway line from Derby to Birmingham opened on 5 August 1839, although the station called Peartree & Normanton came somewhat later in 1890, when New Normanton was rapidly expanding. A road from Normanton to Littleover crossed on a three-arch brick bridge. When the original Derby ring road was built from 1929, it followed the course of this lane, and had to be drastically widened. The bridge was tackled in due course and here we see the station from the down side with the works, finished in December 1935, in progress. Today the station is in sporadic use, but is hard of access due to locked gates and various barricades. *Photographs by Frank Scarratt, 16 July 1934 and 7 May 1935.*

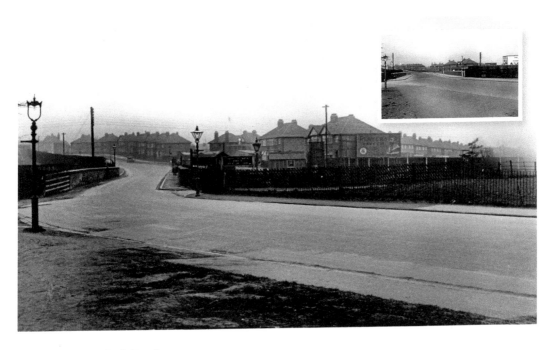

Osmaston Park Road

Between Normanton Barracks and Osmaston Road, Allenton, the new inner ring road was called Osmaston Park Road; it crossed the parkland of Osmaston Hall, sold by the London Midland and Scottish Railway to the council in 1927. Both sides were soon lined with municipal housing, some of which can be seen in the distance. The junction beyond the bridge is of Victory Road, pitched in 1920, to give access to Rolls Royce's new works in Sinfin. Inset shows the same scene a year later, with the bridge widened (*cf. see p. 66 preceding*). It is virtually unchanged today, although the land by the railway to the right is now occupied by a branch of Sainsbury's. *Photographs of 25 April 1934 and 7 May 1935 by Frank Scarratt.*

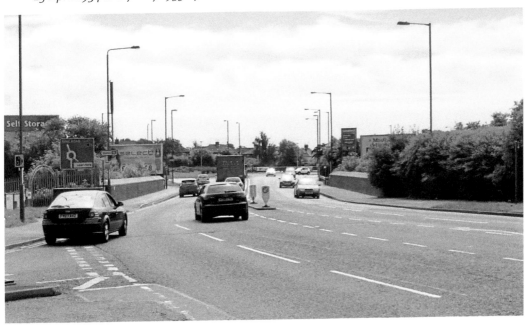

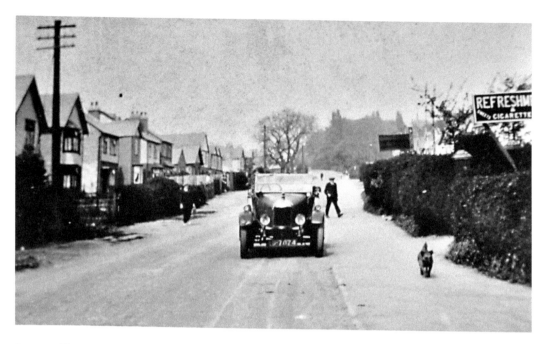

Sunny Hill, Stenson Road

In the 1920s, the agricultural land south of Normanton Village was sold by the Ratcliff family, and built upon. Immediately south of the village lay Sunnyhill Fields, and the housing development here, either side of Stenson Road, was at first called Sunny Dale. Today it is known as Sunny Hill. Development to the west side of the road (*left here*) was halted by the war, leaving a network of pitched and named streets with no houses. When things finally restarted in the 1970s, the pattern and street names were completely changed. The bull-nosed Morris may have been the photographer's car; perhaps the dog making a bid for freedom is his as well. *Photograph by Frank Scarratt c. 1932.*

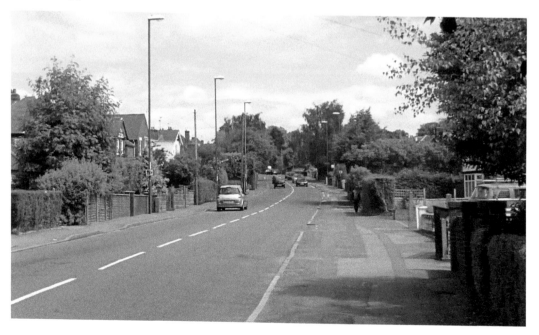

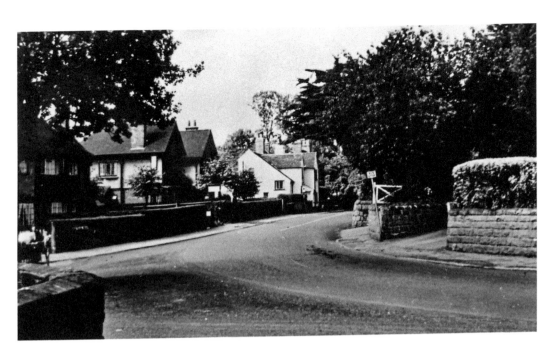

Littleover

Littleover was anciently part of the manorial estate of Mickleover, which lies to the north west. The names mean 'lesser ridge' and 'great ridge' respectively. The ancient route from Sunny Hill to Littleover came up a bosky, sunken lane called Littleover Hollow, and then jinked left and right in order to avoid the hall. The view is of Old Hall Road, looking towards the turn above The Hollow. The road to the left by Home Farm is Church Lane, actually leading to the White Swan Inn, before reaching a place of more spiritual refreshment. On the right, shrubs hide a Victorian villa, The Walnuts, and two later houses built on the hall's grounds. *Photograph from a postcard c. 1937 [Private collection].*

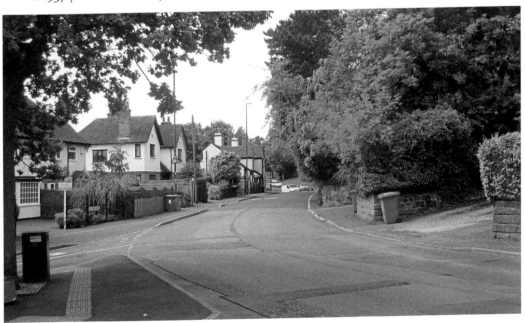

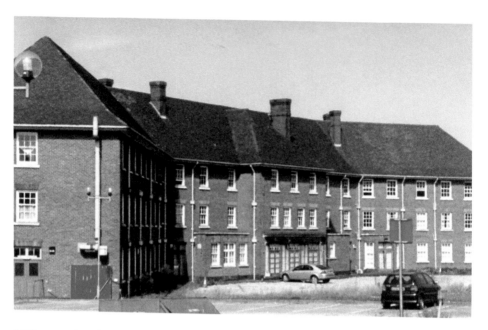

Littleover, the City Hospital

Roughly where Littleover meets Mickleover is a place once called Rough Heanor (now reduced to a farm surrounded by trunk roads), bisected by the long-abandoned course of Roman Ryknield Street. It is here that City Hospital was built in 1931, intended to supplement the Derbyshire Royal Infirmary. It was a handsome exercise in stripped down provincial Baroque revival by Thomas Harrison Thorpe. The neoclassical nurses' home, seen here, was added in 1934, with the south facing façade canted to concentrate the sunlight. Then, at the beginning of the twenty-first century, politicians, encouraged by economies of scale, were persuaded to flatten the complex and amalgamate the two hospitals onto the site, producing a hideous, soulless leviathan in grey metal. *Photographs of 1997 and May 2014, both taken from the same spot in King's Drive, Littleover.*

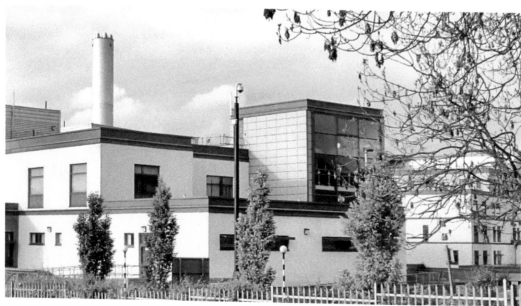

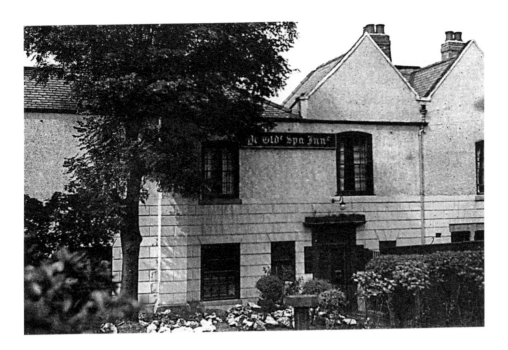

Abbey Street, the Old Spa

The journey back from Littleover to the city centre goes down Abbey Street, a Regency creation of five straight furlongs, named after the pastures of the Abbey of Darley. A 'watering place' as early as 1611, Dr William Chauncey founded a spa here in 1733, which lasted to around 1770, before being reordered as a private house by William Boothby, an upper-class Nottingham iron founder. He extended the building further to the left around 1810, covering it in Brookhouse's Roman cement, grooved to resemble ashlar. In 1832, it was converted into an inn. Vestiges of the original baths remain, and it is still in use as an enjoyable pub (LGII). The rockery made of lumps of local alabaster has disappeared, but a garden remains. The porch was added post-war. *Photograph c. 1936.*

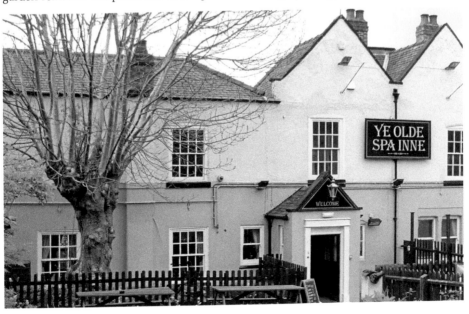

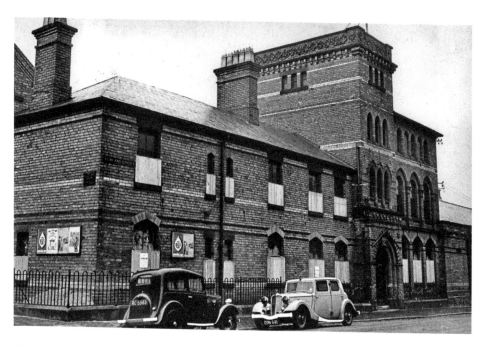

The Newlands, the Drill Hall

From the Derby end of Abbey Street, it is but a short step to Becket Street, the Abbey of Darley's new lands, where the forbidding looking Derbyshire Yeomanry drill hall once stood, with its NCOs' housing alongside and, round the corner in Newlands Street, the Drill Hall Vaults (Frederick Josias Robinson and Robert Bridgart, 1869). The hall itself was vast, the venue for large gatherings and banquets. Redundant after the Second World War, it was demolished in the 1960s, and later replaced by the Irish Club. Note the 1936 Austin Seven Ruby saloon, and what looks like a Lea Francis sports saloon. Note that the Ministry of Defence managed to hold on to their iron railings in the war. *Photograph by Don Farnsworth c. 1955.*

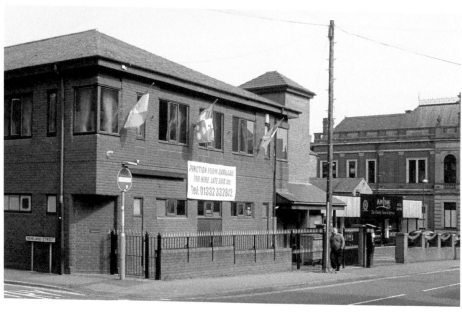

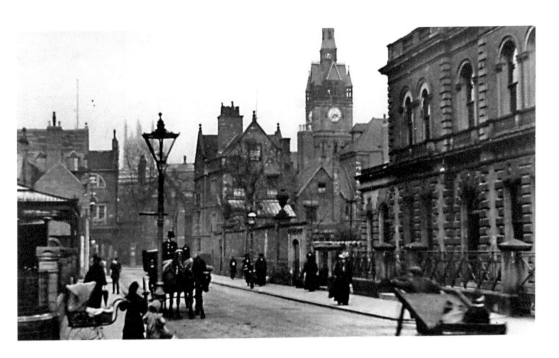

Becket Street

Almost opposite the drill hall stand the former Borough Board of Education offices (Giles and Brookhouse, 1871, LGII). This is a surprisingly neat building that has miraculously survived, despite acquiring a vast office block adjacent on the back garden of the Jacobean House (*centre, background*) in the 1970s. The view is dominated by the tower of the Free Library and Museum (R. K. Freeman 1879, LGII). In the recent view can be seen the 1915 extension of the museum (T. H. Thorpe, LGII). The first floor bay window was the author's office for nearly twenty years. *Photograph c. 1911 from a Frank Scarratt postcard.*

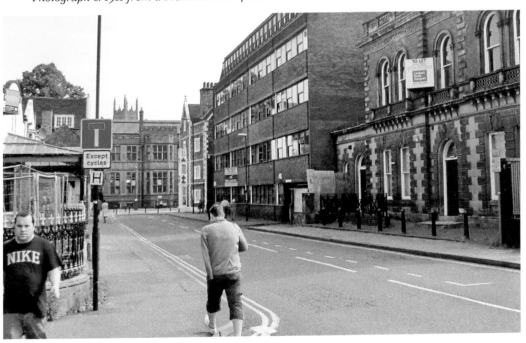

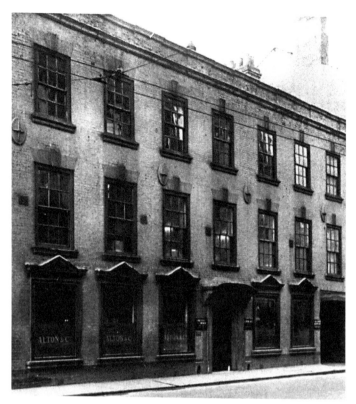

The Wardwick, Allsopp's House

The Wardwick was once a small settlement close to Saxon Derby, but by the twelfth century it had been absorbed by Derby, although the name survives as a street. By the late seventeenth century, it was lined with fashionable houses, including this superb residence, built for Thomas Allsopp in the latest parapeted style, in 1708. The first floor rooms are enfiladed and oak panelled. Allsopp's family went on to be big brewers at Burton, later ennobled as Lords Hindlip. The house passed to a series of Derby brewers: Messrs Lowe, Wedge, Stretton and Alton, from whom it was purchased by Samuel Allsopp & Co., ironically the firm founded by the descendants of the man who had built the house in the first place. They opened it as a pub in 1969. The ground floor was once part shop-fronted and has had its fenestration changed twice.
Photograph c. 1933.

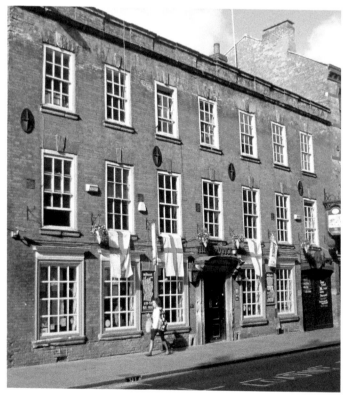

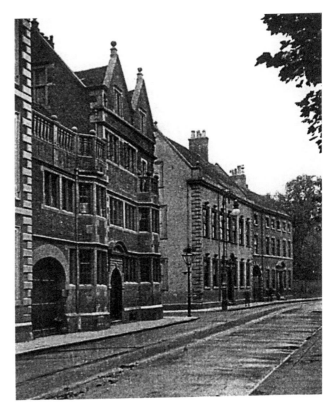

The Wardwick, South Side

A view of the south side of the Wardwick before the buildings were shop-fronted. The quoins of Mundy (of Shipley) House (*c.* 1694, LGII) are just visible (*left*), then comes Jacobean House of 1611 (LGII* *see p. 73*), with Becket Street, where the mouth of the latter's façade once stretched before the street was pitched in 1852. The house beyond is an early eighteenth-century rebuilding of a Jacobean original, but the blind end windows have subsequently been removed and rendered over. Beyond that is Mundy (of Markeaton) House (James Denstone 1767, LGII), now shop-fronted. Beyond, there is a 1890s shop and the Lord Nelson (James Wright, 1892), more recently renamed Aqua Bar and now Deez. *Photograph by Richard Keene Ltd., c. 1895 [Derby Museums Trust L7659].*

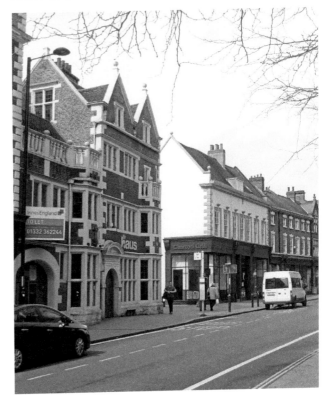

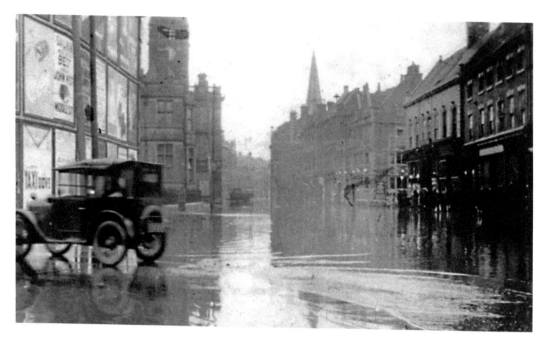

The Wardwick, Cheapside Corner

This is a view back in the opposite direction from page 75, showing the north side of The Wardwick, and the museum looming up on the left background. The 1920s Austin Seven is entering Cheapside, negotiating the aftermath of the devastating flood of Sunday 22 May 1932, when the river backed up. Following this, Herbert Spencer's originally rejected 1841 suggestion – a giant barrier on the Derwent south of the town to prevent this from happening – was rapidly implemented by the council. It never happened again. The 2014 scene is at 11.30 on a Saturday morning, which says it all about the impact of the Westfield shopping centre on the historic core of the city. *Photograph of 22 May 1932 [Private collection].*

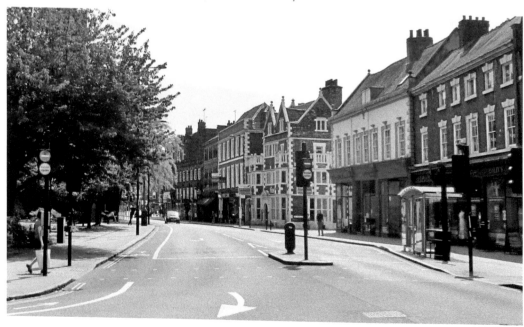

Kensington Street

Dunkirk and Kensington was a small enclave of early nineteenth century artisans' cottages, which grew up on land owned by the Drewry and Harpur families, and around Madeley's silk mill. The Dunkirk name goes back to before 1767, and Kensington is first recorded in 1821, when the streets hereabouts were pitched. They lay south of Curzon Street, which linked The Wardwick with Uttoxeter New Road. Here we are looking down Kensington Street to Curzon Street, giving a distant view of an extraordinarily richly detailed neo-Baroque brick façade, a pair of such houses designed by Alexander MacPherson in the 1880s. Behind the camera is now the great sweep of the new Inner Ring Road, here called Mercian Way after the current incarnation of the Sherwood Foresters Regiment. *Photograph by the late R. G. Hughes c. 1960 [Derby Museums Trust L11227].*

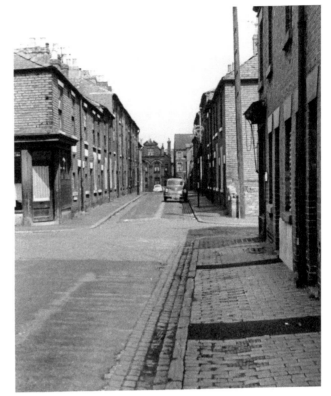

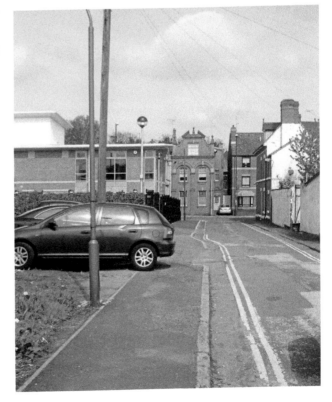

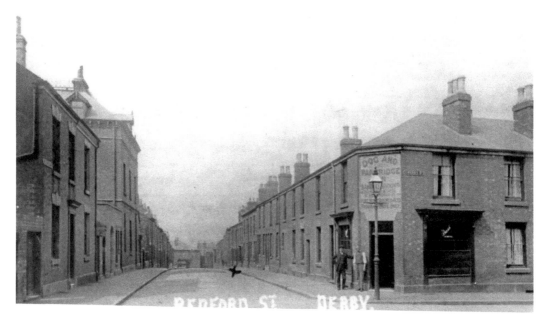

Rowditch, Bedford Street

Bedford Street lies south of Uttoxeter New Road on the edge of the Rowditch/California district, and was pitched by a housing club in 1852–55, but only adopted and extended two decades later. The photograph shows the Dog & Partridge, a beer house on the corner of Crosby Street, opened around 1870 and still an enjoyable place to visit, although it only got a full licence in 1951, and brewed its own ale until 1967. The large house on the left is the former St Luke's vicarage (F. J. Robinson, 1878). Since the 1950s it has been the Bishop Lonsdale Teacher Training College Nursery School. *Photograph from a Frank Scarratt postcard of c. 1905 [Don Gwinnett].*

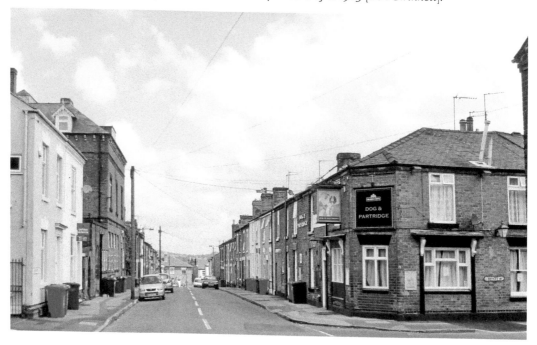

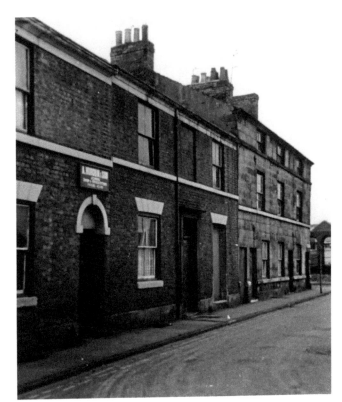

George Street

A little way along Friar Gate is George Street, pitched in 1820 to give access to the new gasworks – a semi-demolished portion of which can be seen beyond the stone fronted cottages built for the workers. The three arches were kept as a feature when a housing association built an ugly new flat complex on the old site in the early 1970s, but were inexplicably removed (without conservation area consent) in 2012. The houses all went in the 1970s as well, and were eventually replaced by a neo-Georgian block of flats in 2010. Out of sight to the right, two good Georgian houses happily survive. *Photograph of 1948 [Derby Museums Trust L5988].*

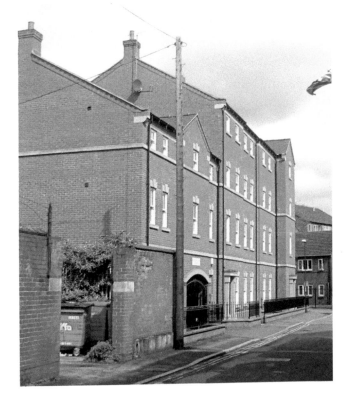

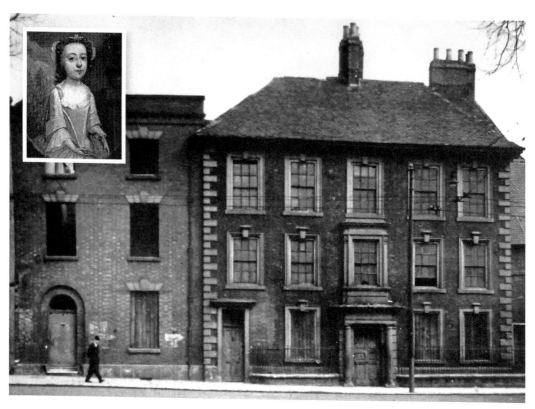

Friar Gate, Queen Anne House
Just before where Friar Gate reaches Ford Street, stood until 1938, what was known as the Queen Anne House. In truth it was a fraction earlier, built for Alderman Gilbert Chesshyre, from whose grand-daughter Kathryn (seen here aged thirteen) it passed to the Cheneys, and eventually to the solicitor Francis Bassano. It was then divided; part of it was occupied by artist A. J. Keene, a son of the photographer, Richard. The grandest rooms were Elizabethan-style on the top floor. It was wastefully demolished for a road widening that did not get done until 2011, after seventy-three years as a car park. *Photograph by Frank Scarratt 24 March 1938; portrait [Derby Museums Trust; Private collection].*

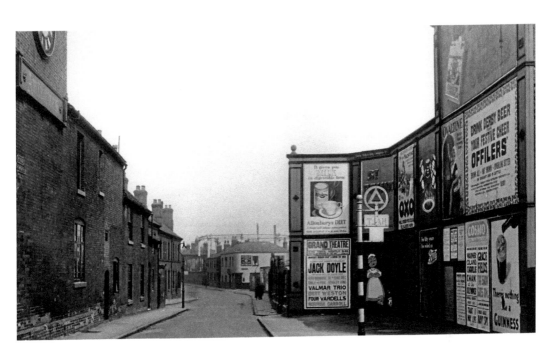

Ford Street

Next to the Chesshyre's house, a few days before, looking east down Ford Street, one sees that hoardings mask the soon to be derelict site. Beyond them, a line of cottages has been partly demolished, but the road has yet to be realigned. On the left is the service wing of No. 27 Friar Gate (LGII*), built by Joseph Pickford for John Oldknow in 1778. The turret clock on the gable was then recently installed by antique dealer Frederick Pratt. The house later became consulting rooms but is now once again a private residence. The white building in the distance is the 1830s Vine Inn, by 2014 long closed, but still standing. *Photograph dated 31 March 1938 by Hurst & Wallis [Graham Penny].*

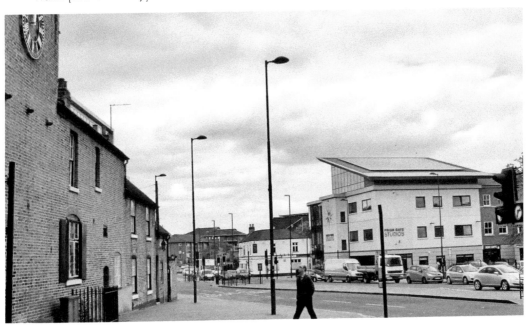

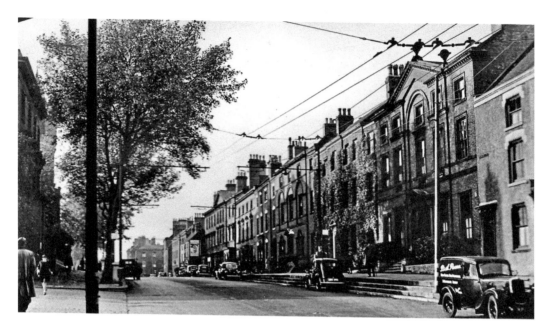

Nuns' Green

In 1768, Derby's first improvement commission acquired all of the land between Ford Street and Bridge Street, on what is now called Friar Gate, and sold the plots for building. This resulted in a superb run of Georgian Houses, with four by Joseph Pickford, including the one with a pediment, which he built for himself, and which since 1988 has been an excellent Museum (1766–68, LGI). Here, we see beneath the GNR bridge (Andrew Handyside 1876 LGII), where the road was lowered in 1904 to accommodate electric trams and, by the time it was taken, trolleybuses. It is wartime, the cars mostly belong to doctors or surgeons, and the iron railings have yet to be uprooted. The London Planes were planted (as in London Road) in 1873. *Photograph of April 1941 [Derby Local Studies Library]*.

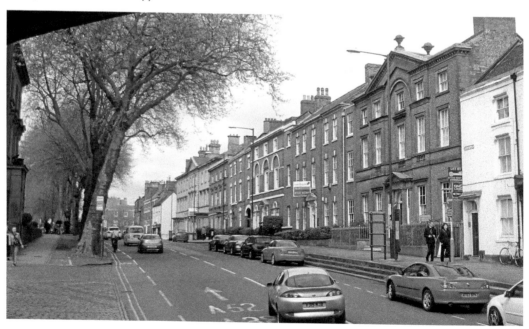

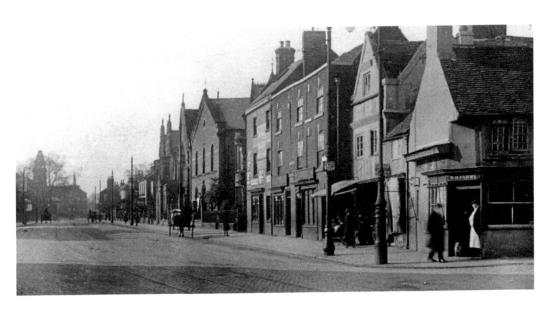

Ashbourne Road, Goodall's Corner

The corner of Ashbourne Road and Brick Street (*right*) is seen here, known as Goodall's corner, from the long established butcher's business in the Georgian building by the CCTV camera. This area and Uttoxeter Old Road (*left, not in shot*) marked the crossing place of Roman Ryknield Street, and the original town boundary. Behind the camera, Friar Gate widened to accommodate beast fairs held there until 1861. In front is the road to Ashbourne, down which Bonnie Prince Charlie marched at the head of 8,000 men on 4 December 1745. The two buildings (*right*) have a medieval core (LGII), but in the 1990s, the chapel, schoolroom and Manse (John Wills, 1885; G. H. Sheffield 1863–65) in the middle distance were needlessly demolished to make way for a block of identikit flats. *Photograph from a Frank Scarratt postcard c. 1908 [Private collection]*.

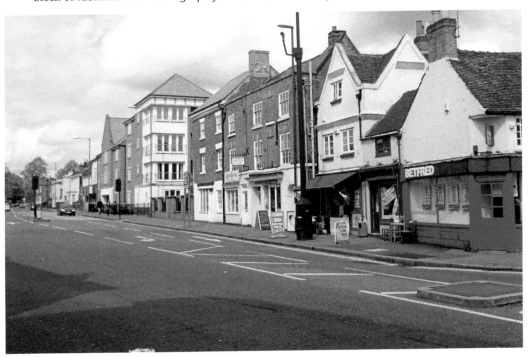

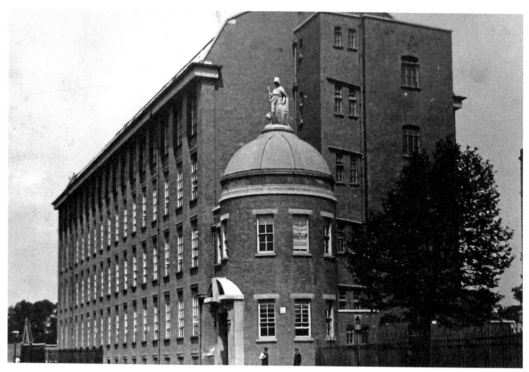

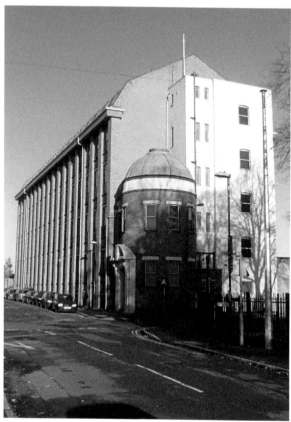

Markeaton Street, Britannia Mill
There has been a mill on the Markeaton Brook at the edge of the Borough since the Domesday Book. In the nineteenth century, the old corn mill was replaced by a textile mill, which was built by Moore, Eady, Murcott Goode, Ltd (as they were latterly). Their Britannia Mill was up-to-the-minute for 1898, with four spacious storeys and a top lit mansard roof. The entrance was via a brick rotunda, topped by a leaded dome and fine statue of Britannia. The firm closed the mill in the 1960s and transferred operations to Leicester, taking Britannia with them. She was last spotted in their yard in Leicester in the 1980s, but has since vanished entirely. University of Derby acquired the building in the 1990s, and converted it tactfully into the School of Art and Design. *Photograph from a Frank Scarratt postcard of c. 1908 [Private collection].*

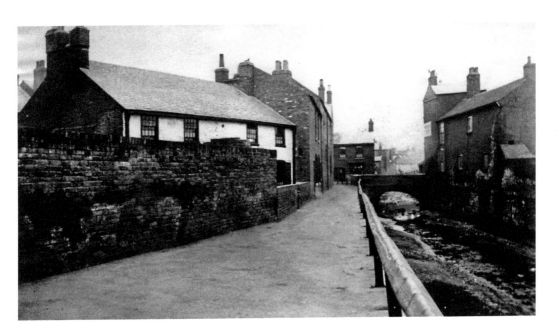

West End, Brook Walk

While the Markeaton Brook was once open from the Derwent to Markeaton Hall (*see p. 90*), by 1871 it was culverted as far as Ford Street, and still is. The area was built up through the release of land by the Third Improvement Commission of 1791. This picture shows Ford Street Bridge in the distance, un-culverted, with modest houses on either side. Most of the mills have come and gone since, to be replaced by bland apartment blocks put up over the past twenty-five years. The widening to the left is Little Bridge Street, now barely a thoroughfare at all. To the right, out of shot, is an iron footbridge crossing the brook to Searle Street. This was replaced in the 1990s, courtesy of the University of Derby. *Platinotype print of a photograph originally taken in May 1855 by Richard Keene [James Richardson].*

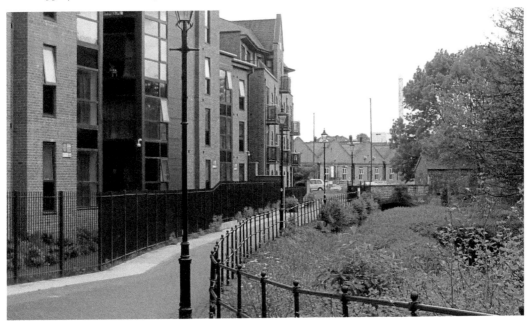

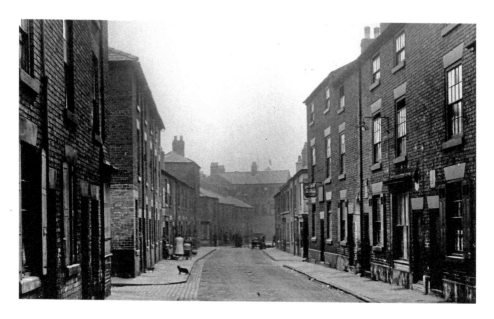

West End, Goodwin Street

Alderman Thomas Goodwin (1633–99) lived at Old St Helen's House and had extensive orchards to the west of his garden, giving us Garden, Orchard, Goodwin and St Helen's Streets, all pitched over the land prior to 1800. They were developed by the Third Improvement Commission, as the easternmost part of what was later called the West End (that grew up on the land liberated by the commission either side of the brook). By the beginning of the twentieth century, large parts of it was slum, interconnected with courts of cottages with little sanitation. Goodwin Street was cleared at the east end by the extension of Walker Lane to form Cathedral Road in 1937–39 (*see p. 16*), and the West End by the building of the inner ring road in 1967. What is left carries neither name nor any buildings. It has opened up unedifying views to the back of the new magistrates' courts on St Mary's Gate (1998). Chapel Street is to the left in both views. *Photograph by Hurst & Wallis 31 March 1938* [*Graham Penny*].

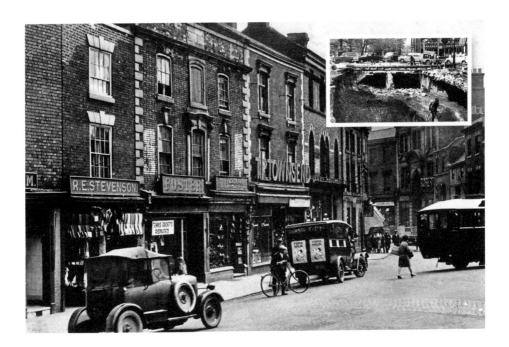

Sadler Gate Bridge

The bridge over the brook, where Sadler Gate once ran into St Werburgh's churchyard (called Cheapside from 1791), vanished into the Strand Culvert in 1871, but the nameplate still remains on the Gothic building, where the van is parked. The so-named street consisted of an agreeable agglomeration of early Georgian houses, the one in front of the car a rather good one. They were all demolished immediately after the Second World War and replaced by a garage, itself turned into a supermarket, but the site acquired some rather lumpish new shops and offices in 2013. The bridge was revealed during sewer improvement works in the 1960s. *Photographs c. 1930 by C. B. Keene & Co., 1964 [Private collection;* Derby Telegraph].

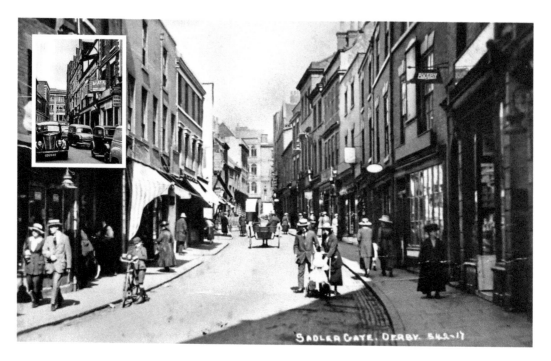

Sadler Gate

Sadler Gate is first recorded in a charter of 1180, when it indeed had saddlers working there; the last, Potts, closed in the late 1970s. Many of the eighteenth-century façades hide much earlier timber-framed buildings, but as a medieval-width street (that Bonnie Prince Charlie's army marched up to get to the market place in 1745), it was always crowded as a century ago (*above*); the situation becomes acute in the age of the motor car (as inset, with pre-war Ford V8, *left*, and Hillman Husky, *centre*, behind a Morris 8 and an Austin A35 van). Since 1963, thanks to a campaign by the Civic Society, the thoroughfare has been pedestrians only. They shouldn't have bothered: the photograph, taken on a Saturday afternoon, shows it deserted. *Postcard photograph of 1907 and another of 1961* [*latter,* Derby Telegraph].

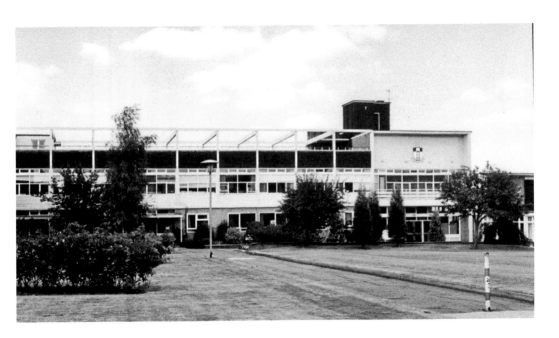

Mickleover, Chevin Avenue

In 1852, a college was opened on Uttoxeter New Road in Derby 'For the Training of Schoolmistresses', designed by H. I. Stevens. In 1960, the institution re-branded itself the Bishop Lonsdale College, admitted its first male students, and in 1964, expanded to a new site in Mickleover, on part of the former Markeaton Estate. The new building, the top floor of which was never completed due to the tendency of the land to subsidence, formed a *cour d'honneur* flanked by female students' lodgings and an assembly hall. In the 1970s, it took over the county's higher education college, and in 1992, the institution became the University of Derby. The spacious and airy site was dispensed with, the building destroyed, and all was sold for the building of vast numbers of uninspiring houses. A fine bronze statuary group from the gardens by sculptor Charles I'Anson (1966) appears to have gone AWOL. *Photograph of 1974.*

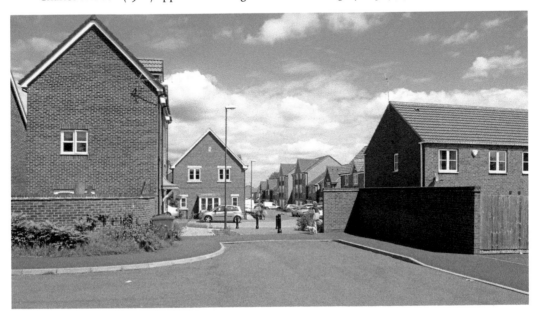

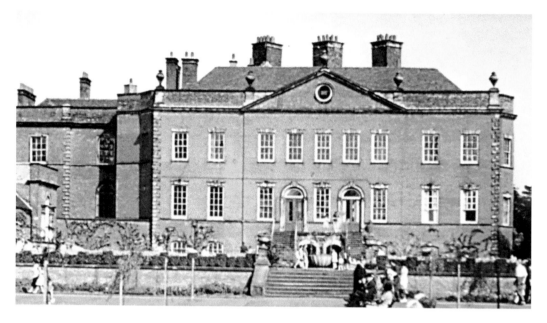

Markeaton Hall

The Mundys acquired Markeaton Hall from the Touchets, Lords Audley in 1516, and replaced their early Tudor house in 1755 to the designs of James Denstone of Derby, as seen above. The house (LGII) was extended in the 1790s, and the orangery and hunting stables (a corner of which is visible, *left*) added by Joseph Pickford for F. N. C. Mundy in 1772. The house and grounds were acquired by the borough council in 1929, and the building was unnecessarily demolished after two decades of neglect in 1964. The site was under excavation in the recent view, seen here in June 2014. In the meantime, the Venetian fountain had been moved and the superb pair of bronze Warwick vases at the top of the steps stolen, along with the Bakewell weathervane on the stable block. *Photograph of 1962 taken by the late Edward Saunders.*

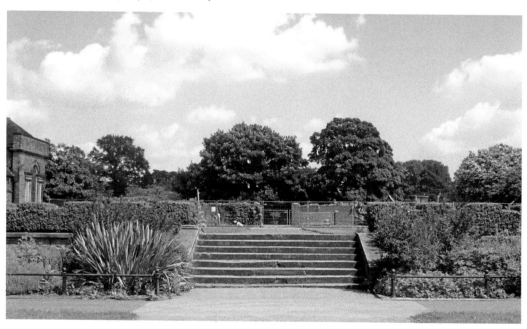

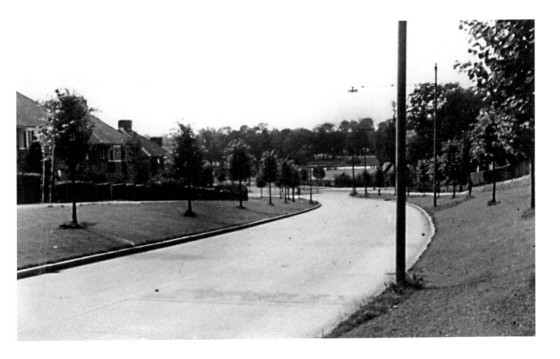

Darley Abbey, Broadway

Once the borough boundary had been extended in 1929, the inner ring road could be started. By 1939 it had reached the gates of Darley Hall; only the war prevented the desecration of its William Emes park. This is the pitch up to that point, made up of jointed concrete sections, with wide verges and trees, looking back southwards to Markeaton Park beyond the intersection with the Kedleston Road. Today, the pre-war villas are well protected from what little traffic remains after the opening of the A38 extension (*adjacent*) by the mature lushness of the seventy-five-year-old planting. The road now turns a sharp left at its foot to avoid the new trunk road. *Photograph by Hurst & Wallis of 1938* [*Graham Penny, Esq.*].

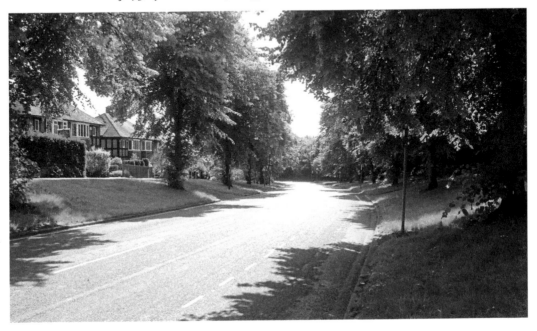

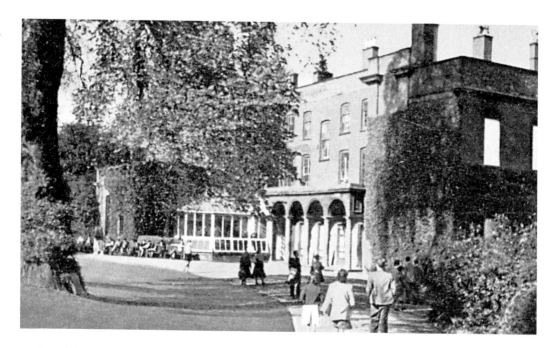

Darley Abbey, Darley Hall

The Abbey of Darley was founded around 1135, and was the largest in Derbyshire until dissolved in 1539. The site became secularised and a new house, probably on the site of the Abbott's lodgings, was built to the designs of Francis Smith of Warwick in 1724, for Alderman William Woolley of Derby (LGII*). The estate came to the Holdens, who had Joseph Pickford enlarge the house and William Emes landscape the park, 1778. They sold to the Evanses, who had founded a large cotton mill in the village in 1782; they had Moses Wood of Nottingham add the loggia. The house (LGII*) in 1929 came to the council, who failed to find a use for it and, after housing Derby Central School for a few years, was wilfully demolished in 1962. A small fragment has been left behind, which acts as an ice-cream parlour. Mercifully, the spectacular parkland remains.
Postcard photograph c. 1955

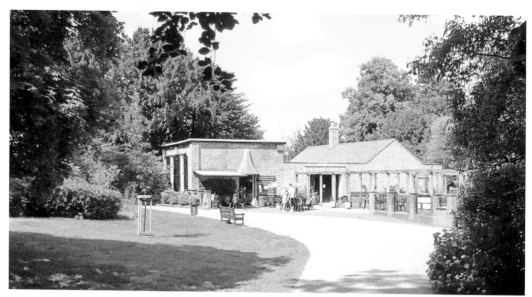

Darley Abbey,
The Old Round House

This engaging little structure was erected (probably by the Evans family) in the 1830s, by the hall gates as a watchman's lodge and lock-up (LGIII). Alternatively, it might originally have been put there by Pickford or Emes in 1778 as a lodge, and merely enlarged (behind) by the Evanses. Beyond is Mileash Lane, pitched with a terrace of houses (those visible being mid-nineteenth century), again by the Evans family, in order to connect the mills with the main turnpike road (now the A6 Duffield Road) to Derby. The building went into terminal decay after the death of the last Evans in 1929, and was demolished to improve the road in 1954. *Postcard photograph of c. 1905 [Private collection]*.

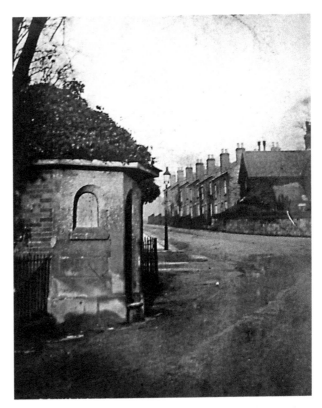

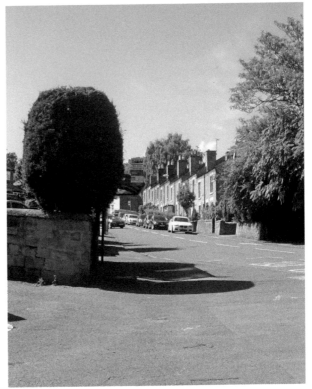

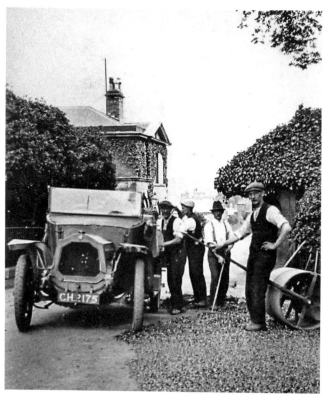

Darley Abbey, New Road
New Road was pitched in two stages either side of 1811 to connect Darley Street with Mileash Lane. At the upper end, on the corner with Brick Row, stands Darley Abbey School, designed by Moses Wood for the Evanses in 1824. It is easily the most handsome regency building in Derby (LGII). It is now divided to accommodate businesses. A jolly group of hall staff pose for the camera by the agent's car, with the ivy-covered roundhouse (*right*). *Photograph* c. 1920 *[Bamfords Ltd.]*.

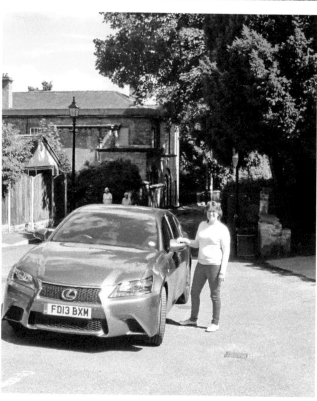

Derbyshire Through Time
Margaret Buxton-Doyle

This fascinating selection of photographs traces some of the many ways in which Derbyshire has changed and developed over the last century.

978 1 84868 517 8
96 pages, full colour

Available from all good bookshops or order direct
from our website www.amberleybooks.com